PhotoPainting

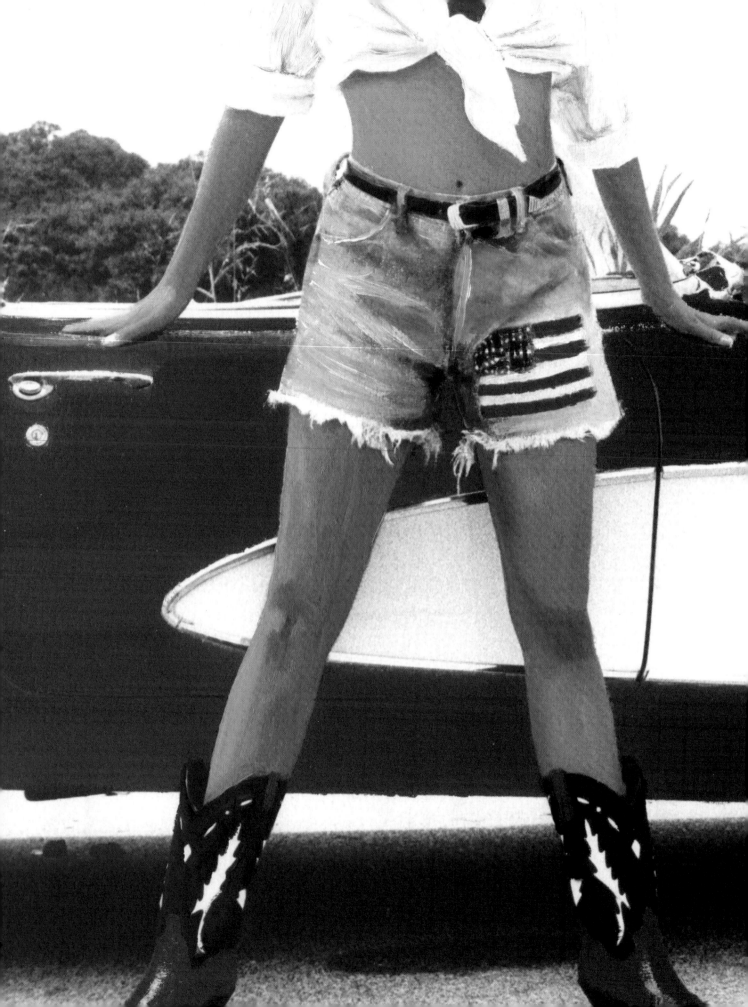

PhotoPainting

THE ART OF PAINTING ON PHOTOGRAPHS

JAMES A. McKINNIS

AMPHOTO BOOKS

AN IMPRINT OF WATSON-GUPTILL PUBLICATIONS | NEW YORK

PhotoPainting
Copyright © 2002 by James A. McKinnis

First published in the United States in 2002 by
Amphoto Books, an imprint of Watson-Guptill Publications
a division of VNU Business Media, Inc.
770 Broadway, New York, New York 10003
www.watsonguptill.com

Library of Congress Control Number: 2002108831

ISBN: 0-8174-5511-6

Typeface: Minion

Senior Acquisitions Editor: Victoria Craven
Editor: Amy Handy
Designer: Barbara Balch
Production Manager: Ellen Greene

Manufactured in the U.S.A.

First printing, 2002

1 2 3 4 5 6 / 07 06 05 04 03 02

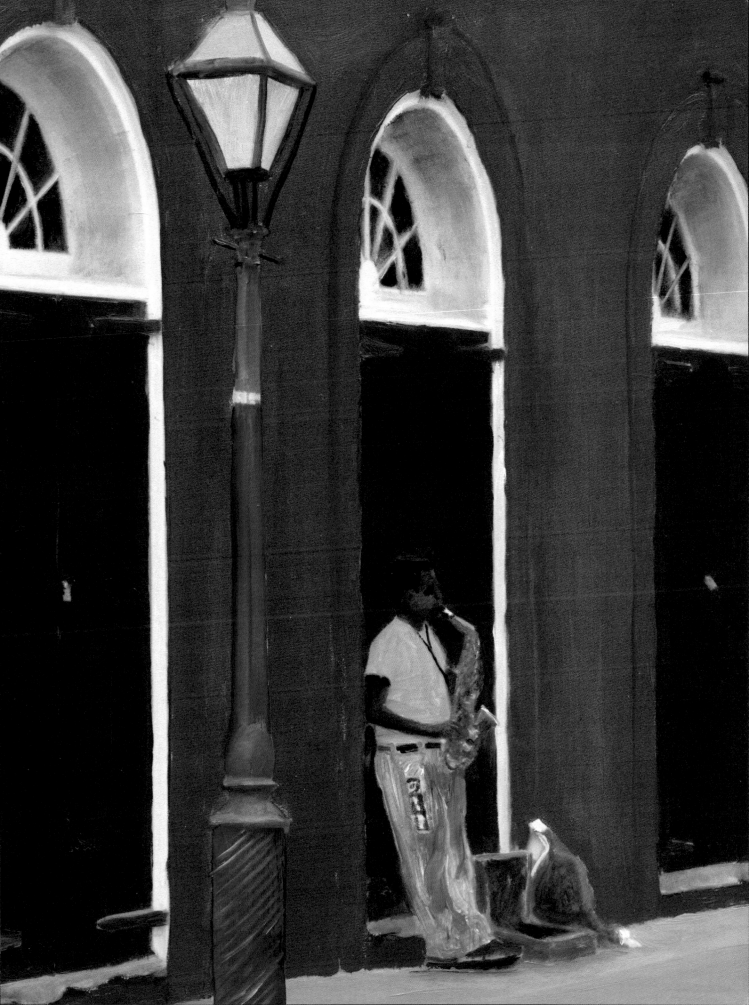

Contents

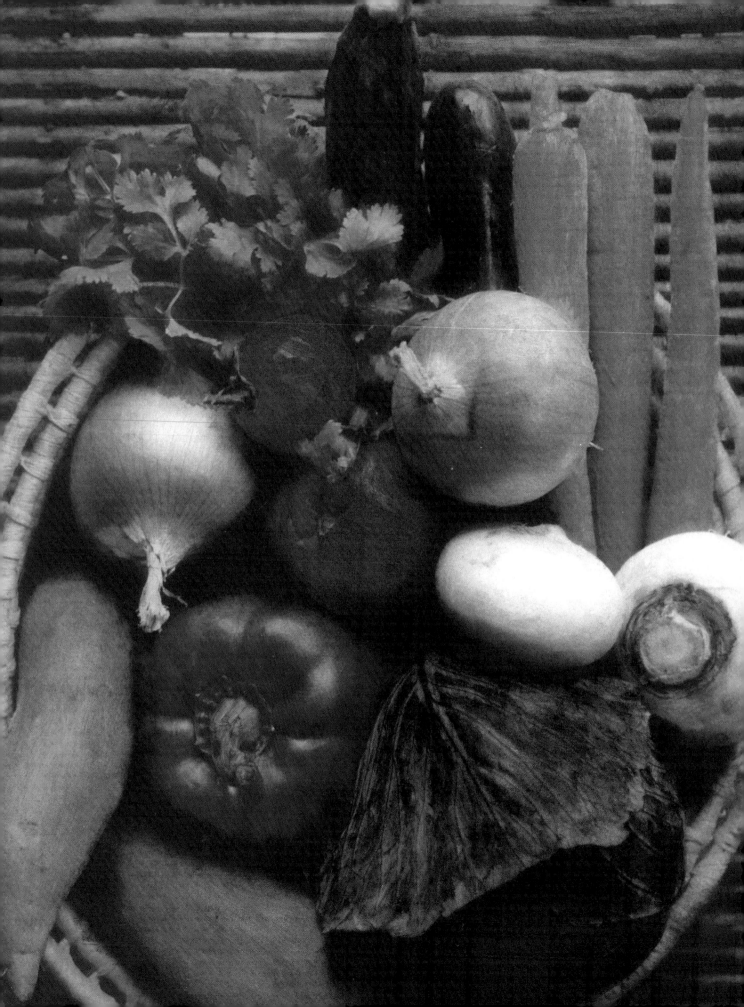

Why Paint a Photograph?
In the Beginning. . .

Why not?

As T. S. Eliot said in "Four Quartets," we should never stop exploring, and in the end we will return to where we started and will have made discoveries along the way. We need not limit in advance our explorations; otherwise, who knows what we may fail to discover? Way back when, I was a photo-tinting purist. To me, handcoloring photographs successfully was a matter of strictly sticking to my "cotton-swab application and cotton-ball rub-in" technique, made famous in my previous book *Handcoloring Photographs.* No matter how intense you wanted the color, you always rubbed it into the print. You left no evidence of the photo oil as texture or opaque application—the entire image showed through the translucent color. Period.

In late 1989, some factors coincided to change my way of thinking. A Dallas Cowboys cheerleader shoot, from which I was commissioned to deliver an ultracolor tint—my term for a vivid, attention-grabbing handcolored image—for a poster, resulted in a series of unusable images due the background, an empty stadium. An alternative venue was chosen for the final image and the poster turned out well. At the shoot, I met an individual with the organization who invited me to photograph a game from the sidelines. It would be my first football pictures since a brief and undistinguished stint as an annual staff photographer in high school.

The fates were evidently planning something for me. During this time, I had a good rapport with the editor of

a magazine in which my first national article on hand-coloring photos was set to appear. Through him I was able to obtain a press pass to my first race event, an IMSA Grand Prix in San Antonio, near where I lived. My first day at the race practices resulted in a great picture (I thought so, anyway) of a Nissan GTP. Its color scheme was a brilliant royal blue, white, and red. In my black-and-white shot, the royal blue was rendered a dark gray. After the races were over and I began working on some of the pictures, I found that no matter how hard I tried, I could not get an equivalent of the brilliant blue with the base gray in the photograph. Even using Marshall's Extra-Strong Ultra Blue, which was itself an intense, albeit "transparent" photo oil, I had no success. My ultra-color effects worked their magic in the light gray areas of the photograph, but the darker the background gray, the less effect the photo oil had. I had apparently entered a black hole, from which no bright blue emanated.

Frustrated, I decided to add a dollop of Titanium White to the Ultra Blue. As I mixed the two on the palette, there was the royal blue I held in my mind's eye. I was elated! Immediately. I pulled out a print and began my tried-and-true technique, and instantly my spirits sank, even lower than before. Not only did the royal blue disappear as I rubbed it in, the Titanium White left a milky residue, "fogging" the underlying photograph. The reason: Titanium White is opaque. I had a major problem, almost a catch-22. I could put the color on the photo but then the image would not show through the opaque color. At the time, completely covering the image was unthinkable. Yet I wanted that picture—handcolored! I dimly began to realize that I had one

OPPOSITE:
Couscous Vegetables

option. I had the photograph and I had the color I wanted; now I had to slowly, deliberately "paint" the picture. At that moment I began teaching myself "photopainting," and at first I called my results "painted images." There was a lot of trial and error, but I finally wound up with my picture—handcolored! (See page 126 for a similar image, where I managed to get the blue right!)

Amazed to discover that I liked the effect, I dug out the cheerleader photo with the empty stadium and "filled" the seats with dashes of abstract color (admittedly borrowing the effect from Leroy Nieman). The cheerleader poster was already "history," but the lesson from the rejected image has lasted to this day. I now use abstract colors in most of my sports work.

I went nuts with these "painted images." I called the aforementioned magazine editor, who accepted my premise for a new article, and I went out there shooting sports events, cars, and women with wild abandon. After this second article was published, I soon discovered that my enthusiasm for the medium as I had developed it to that point cooled for subjects other than sports. Ironically, although I had always loved sports, from my earliest years I had avoided ever considering photographing the subject professionally. Yet I immediately found that the heavy oils and bright, intense colors captured the passion I felt for the game. And my sports images succeeded quite well, being acquired by some collections and galleries, and sometimes even by the players themselves.

Throughout the 1990s, there was a dichotomy in my work: I photopainted the sports images and handcolored everything else. It would take another epiphany almost coincidental with the end of the last millennium to bring me to this book. My wife was preparing a cookbook for a family Christmas project and I had begun tinting *Couscous Vegetables* for the cover (page 8). On impulse, however, I brushed on some artists' oils and left the application judiciously thick and opaque here and there, to highlight the strong colors of the tomatoes, carrots, and other produce. I made no attempt to reduce the visible texture of the brushstrokes, which—

according to my iron-clad rules on tinting—were jarring. Once again, I liked it! I liked it so much I immediately called the my editor at Amphoto Books and said I wanted to do a new book.

My next project was a photo of a Santa on an old tractor, one I had taken four years earlier. The background and tractor had so much detail that I never had felt like tackling it. However, Christmas was approaching and on impulse I dragged out my remarkable fast-drying Winsor & Newton oils, squeezed out some green and red on my cardboard palette, and dabbed paint here and there. I loved it and sent one to my Amphoto editor as a holiday card (page 58).

I began to look for other images that either I had left incomplete (for whatever reason) or that seemed appropriate for this new technique. I started with a shelf of boots. I had wanted to do a series of boots since they seemed quintessentially "Texas," and this was the first "good" work from that idea. As I painted each individual boot, I felt the subject come alive and begin to feel three-dimensional. Since there were no pairs, I called it *Texas One Step*. (See pages 69–71 for a step-by-step demonstration.)

As I prepared examples for this book, I also revisited pictures I had earlier done very satisfactorily as "tints." Nothing was immune from my brush and oils!

And so I now return to the question: Why paint a photograph? I love the photograph, and have committed my professional life and my family's welfare to it. I was seduced by the camera after ten years in another profession in which I had done quite well and to which I had devoted years of schooling and two degrees. I then set out as an adult to teach myself photography and for the first few years I felt like a thirty-something first grader. Humbled by the experience, I prejudiced myself by consciously avoiding certain areas of photography that, while perhaps financially more attractive in the short run, seemed so deadening creatively. Then I latched onto the field of handcoloring, which was considered dead at the time. I struggled to learn that field, and succeeded.

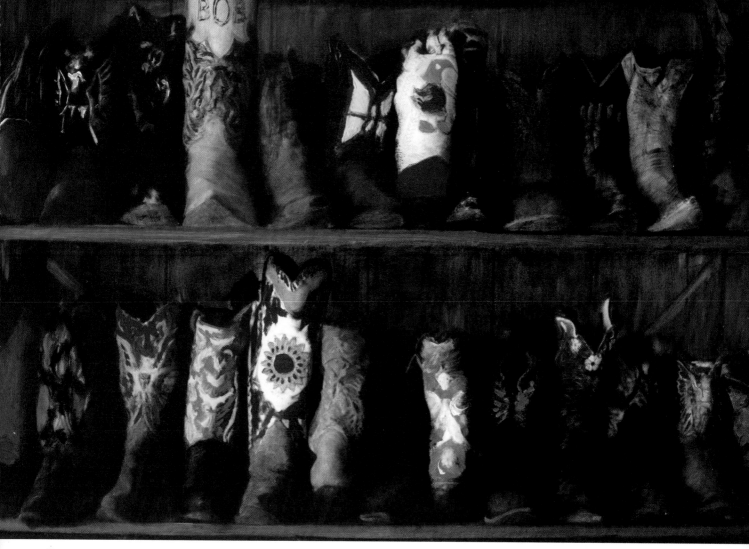

Texas One Step

But the artist in me heeds Eliot's advice on exploration. Why stop there? I am free through my creativity and curiosity to explore any direction. I may not succeed in finding anything of interest, but at least I'll have made the journey.

One fundamental lesson I learned right away: photopainting makes you look at a photograph far more closely—the effects of light and how it affects shading, the shapes, the depth of the shadows, the nuances that otherwise are largely overlooked. Should you paint all your photographs? Some of mine I prefer as black-and-whites. Do I have the right to add paint to my photograph if I want to? Certainly! Would I add paint to Ansel Adams's *Moonrise, Hernandez, New Mexico*? Let's not go there. However, the simple fact that

the image is a photograph and not a blank canvas does not preclude me from adding paint to it.

Will I improve the image? I won't know until I see it. A knowledgeable friend called one work a "half-assed Degas." Not everyone accepts photopainting. Still, I think it's important to explore. This isn't Russian roulette; it's painting on a photograph, and I'm having a blast with it!

Throughout this book I have provided you with many finished examples of what I've done, as well as a series of twenty photopainting demonstrations with step-by-step images and instructions to teach you how the process works. Photopainting does require a fair amount of patience and practice to get used to finding your way after "hiding the photograph." But see for yourself. You may like it.

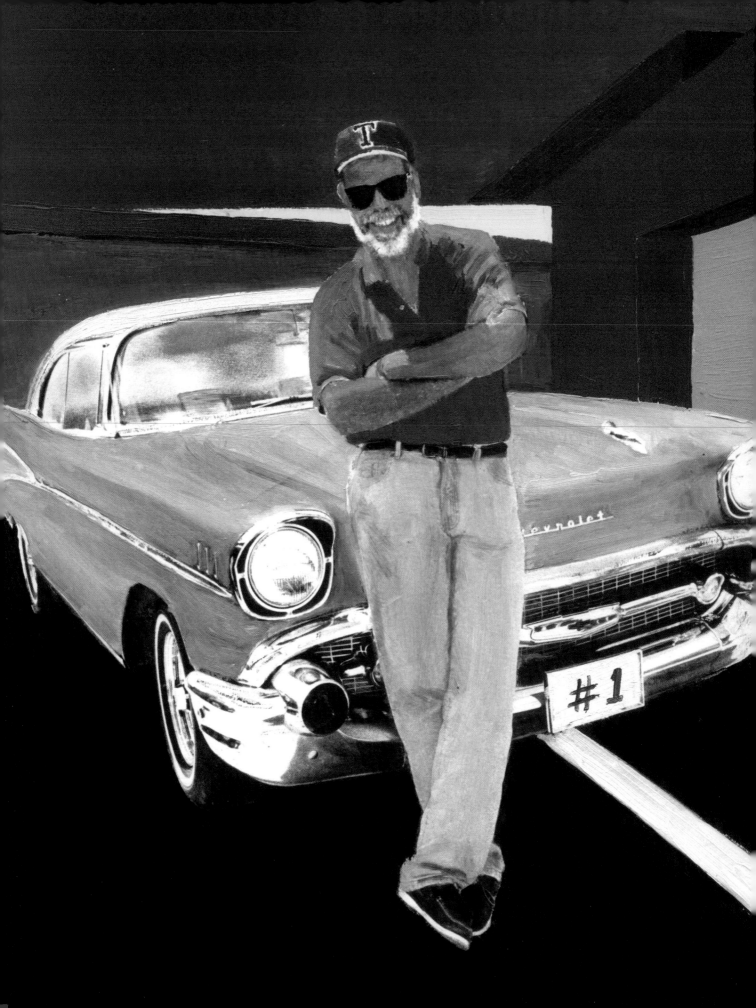

A Photopainting Portfolio: Touring My Collection

Since most of my photopaintings are new and therefore have not been published before (at least in book form), I thought I would begin with a "tour." As I am sure you will recognize, what you photograph tells a lot about you as a person: your interests, your pleasures, your concerns. In essence your body of photographs helps form the mosaic of who you are.

In *Numbah 1* I'm standing in the hot Texas sun, taking a picture of myself. I don't usually do this, but the image was requested a few years ago for the cover of the video version of *Handcoloring Photographs.* Since I had nothing more recent of myself, I decided to see how it would look as a photopainting. You might infer that the classic '57 Chevy I'm leaning against is mine. Wrong! But I do like the Texas Rangers, classic cars, and bright colors. This photopainting (compared to the unaltered image) covers up the background and pavement through the use of abstract solid colors and geometric patterns. One quality I really like about photopainting is that I can modify the picture considerably more than with tinting. I do not call this retouching! But "artistic license" I will accept.

My very favorite subjects include attractive women and great old cars, either together or alone. *American Beauty* (page 60) is an image that can be read on a couple of levels. As a photopainting, it illustrates the approach that combines painting with leaving a portion of the photograph untouched. I chose to limit the colors to basically red, white, and blue to follow the theme. (See pages 60–61 for a step-by-step demonstration of *American Beauty.*) *Diner Dreams* (next page), on the other hand, also relies on the car/woman theme but employs a color-saturated scheme. I did manage to curb my wildness for color a bit and actually got the colors of the car very accurate, in both the owner's opinion and my own.

It is important to note that these are *photopainting*s and not alternative color images. In other words, when oils are used in this manner, no matter how "photo-accurately" the paints are applied, the images do not look like color photographs. They aren't supposed to! No matter the intent or the skill level of the one handling the paint, the qualities of artists' oils will render a texture and feel that clearly distinguish photopaintings from photographs.

OPPOSITE:
Numbah 1

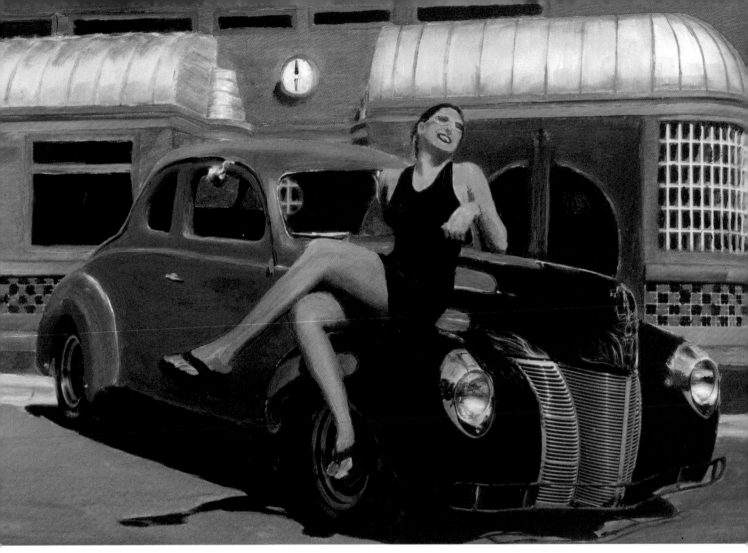

Diner Dreams

Taos Village

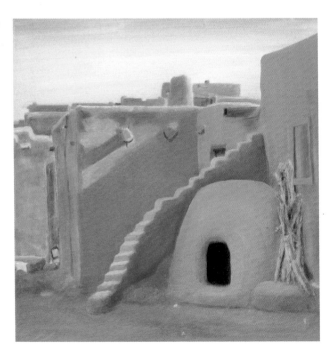

Sometimes you will finish a photopainting that doesn't quite satisfy you. It comes with the territory. My first attempt at *Taos Village* (opposite) left me feeling that I was looking at a stylized cheesy image in some strip-mall "southwestern art" gallery. Since taking the image eleven years earlier, I had left well enough alone by only printing and brown-toning it. I had never tinted it or otherwise manipulated it. I finally decided that the problem was that the sky was too "cute." When I over-painted it with a more natural sky look I found it satisfied me much better. So don't ever be afraid to rework an image later if you want to. I won't tell.

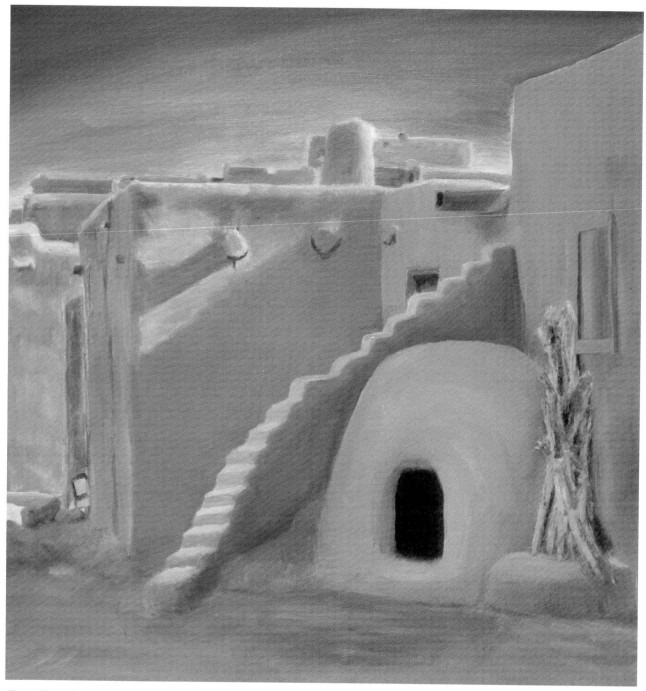

Taos Village (Revised)

If *Texas Ballet* (next page) looks familiar, you probably saw a very similar work in *Handcoloring Photographs* called *Once Upon a Time at the Y-O*. Each of these actually came from different negatives, hence the different titles, but the story is the same: The Bolshoi Ballet was scheduled to visit San Antonio and I arranged a commission with the local promoter to do a work for a fundraiser. I envisioned a cowboy, a longhorn, and a dancer on the flat Texas plains. When I arrived at the famous Y-O Ranch for the shoot and told them my idea for the picture, they responded, "There ain't no way we're lettin' this longhorn outta this here pen. He'd

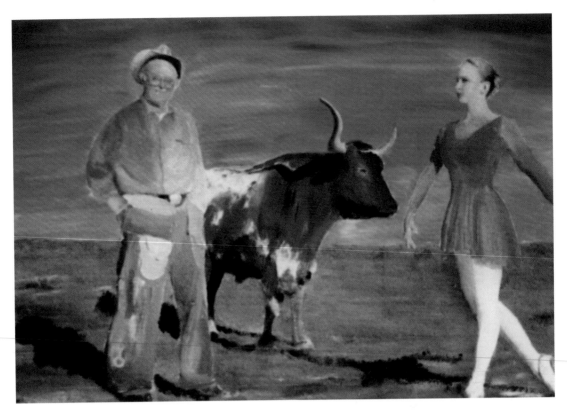

Texas Ballet

never stop runnin'." So I contented myself with shooting within the enclosure and the shoot turned out very successfully. Nevertheless, the decade that passed since this shoot did not diminish my idea of how I had visualized the image. So, armed with my new photopainting technique, I attacked the work again and *Texas Ballet* resulted. I finally had my longhorn on the Texas plains . . . and

he didn't run away! (See pages 98–99 for a step-by-step demonstration of *Texas Ballet*.)

Sometimes a place is so outrageous that we hope it remains forever unchanged. I will always be grateful that I took advantage of the beautiful afternoon light of a rare sunny day in rainy Seattle to preserve the memory of the Hat and Boots gas station. When I returned

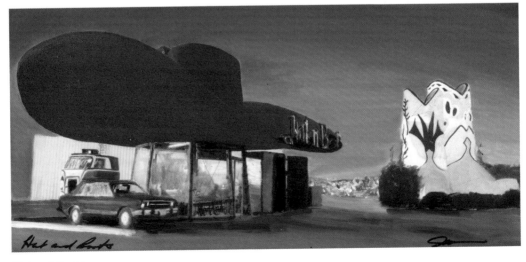

Hat and Boots

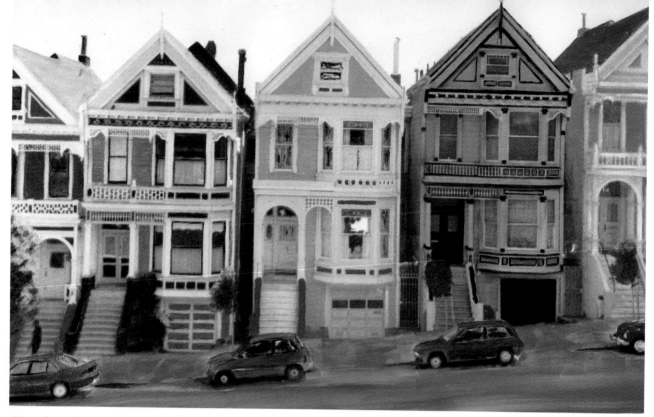

Gingerbread

many years later I searched in vain before learning that a wrecking ball had leveled it. Apparently the land value had increased to the point that developers could justify destroying beauty for profit. (See pages 74–75 for a step-by-step demonstration of *Hat and Boots.*)

In some places, such as San Francisco, certain residential styles have fortunately maintained such a universal and unique appeal and an identity with the community that they have been continually preserved. It is reassuring to know that these *Gingerbread* houses will still be standing on my next trip to the city.

San Jose Mission is another reminder of our good fortune at recognizing our history and not abandoning all our old buildings. Obviously the fact that it was a church gave it a greater, more permanent presence in the community and probably helped preserve it. This photo-painting appears to be a tint but is actually a "mix" in the sense that I applied a reworking of additional artists' oils to details of the mission to accentuate the ornate carvings and other important features. (See pages 102–103 for a step-by-step demonstration of *San Jose Mission.*)

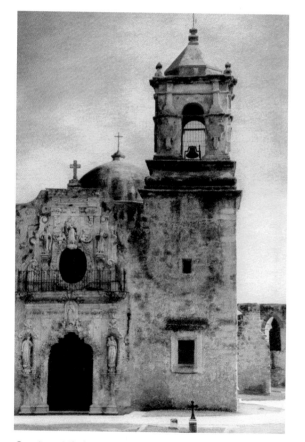

San Jose Mission

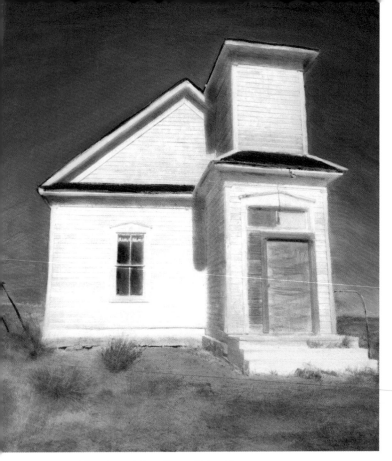

Abandoned One-Room Schoolhouse

I label myself a "reactive" photographer. By this I mean that I tend to react to something that catches my eye. In the next few photopaintings, I have reacted to the sense of abandonment, the passage of time, the deterioration that comes from the inexorable erosion of nature. In some cases a sadness results, a mirror held to our faces that shows how time will affect us. One can infer the hopes and expectations that were there at one point, now gone. *Joe's Garage* advertised itself as open seven days a week, and the shouts of the kids are no longer heard in the little abandoned *Schoolhouse.* In a sign of earlier times, *Refreshes Without Liking You* requires you to do a double-take when you see the old 7-Up ad peeking through the later Pepsi banner. When was the last time the last Kaiser in Clarendon was driven?

In *Kaiser* I employed a different kind of photopainting, which appears more like a tint. I used a brush with the artists' oils "crushed" into it, rendering the feel almost dry. I call it the dry-brush technique. It qualifies as a photopainting because one can still see the texture of the brush strokes on the surface of the image. (See page 62 for a step-by-step demonstration of *Kaiser.*)

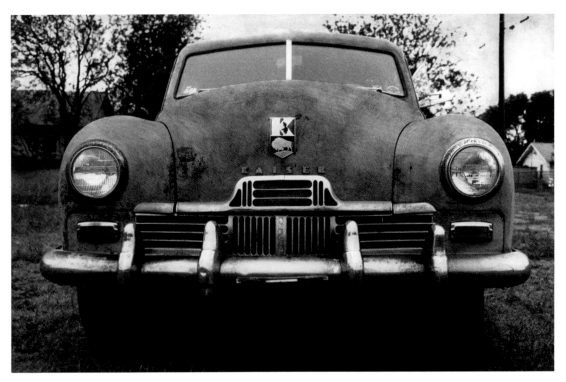

The Last Kaiser in Clarendon, Texas

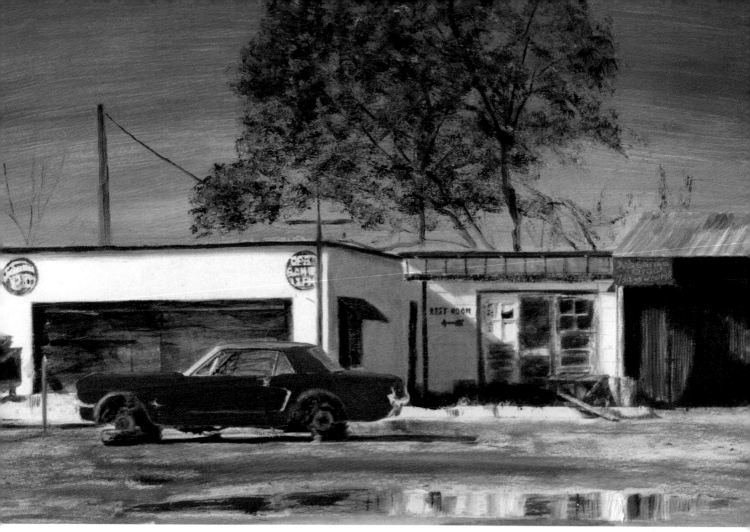

Joe's Garage

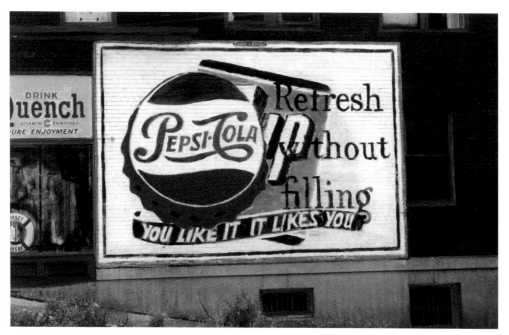

Refreshes Without Liking You

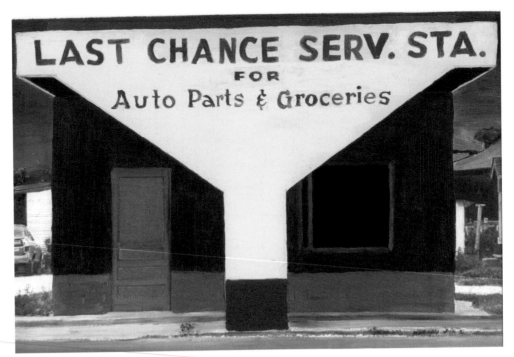

Last Chance

Vets Garage

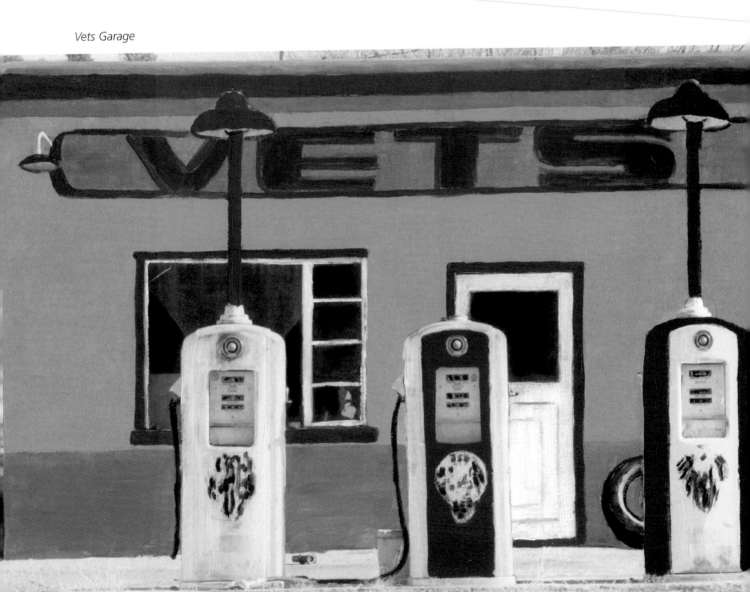

With their decades-old look and feeling of abandonment, *Last Chance* and *Vets Garage* both continue the theme of deterioration and lost time, yet their vivid colors give the scenes new life.

Once in a while an anachronism manages to hang on, even though you know it's bound to disappear soon. Some years ago I spotted perhaps the last penny gumball machine I would likely ever see. I think I was right.

The Last Thing in America You Can Buy for a Penny

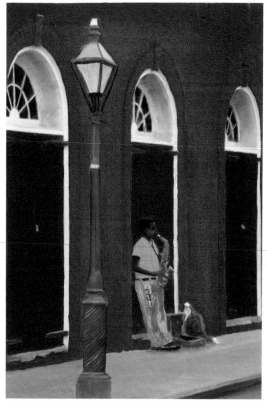

Sunday Morning off Bourbon Street

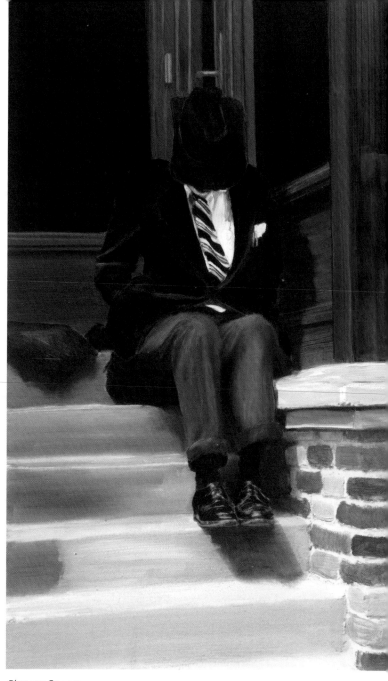

Pioneer Square

The life of the musician is the life of the artist, filled with the quest to pursue a calling that often defies reason, to create beauty whether anyone else cares or not. There is dignity in suffering for your dreams and pursuing what your feel uplifts the human experience. *Sunday Morning off Bourbon Street* appeared in my first book and now makes a reappearance as a photopainting. Since this is not an audio book, I leave the sounds of the saxophone to your imagination.

I love dignity. *Pioneer Square* still challenges me with questions twenty years later. I walked by this gentleman, whom I took to be homeless, dozing on the steps of a restored building in Pioneer Square in Seattle. He appeared old and tired; his pants were rolled and he had a blanket with him as well as his overcoat. Yet he wore a tie, pressed shirt, coat with pens in the pocket, and polished shoes. If indeed he was down on his luck, he had not surrendered one iota of his self-respect.

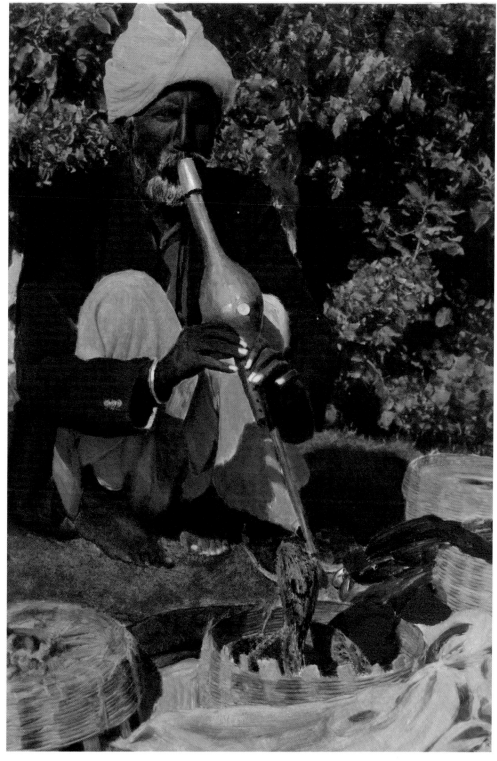

Snake Charmer

When we traveled to India many years ago I was shooting mainly color slides, so I had only a few black-and-white negatives to work from when I got tempted to handcolor them. *Snake Charmer* actually appeared in my first book as an illustration for the basic handcoloring process. Now I have reworked it as a photopainting.

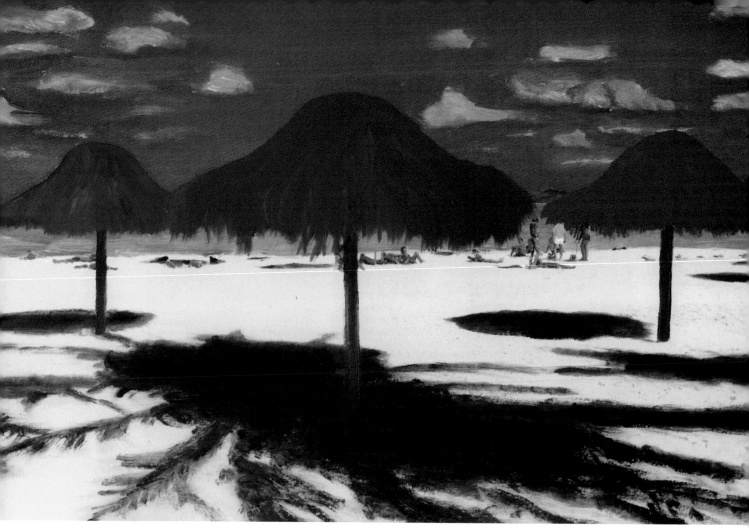

Too Many Margaritas in Margaritaville

Unfamiliar places often stimulate our urge to point the camera and record. Vacations provide us with the perfect opportunity. In the Bahamas, I reacted to the thatch "umbrellas" on a Nassau beach. *Too Many Margaritas in Margaritaville* also appeared as an ultra-color image in *Handcoloring Photographs,* with a similarly outrageous color scheme as in this photopainting. I think it captures the feeling of a tropical vacation very well.

Entering a harbor on a windjammer cruise in the Caribbean, I shot *Caribbean Lighthouse,* a color slide of the morning scene I beheld (opposite, top). I had the slide made into a print and kept it in one of my portfolios, until curiosity eventually got the better of me. I copied the image to secure a black-and-white negative and sought to discover how the photopainting would compare (opposite, bottom). Judge for yourself.

In the course of my photopaintings I found myself veering painfully close to certain painters' styles. (You might recall that "half-assed Degas" comment I mentioned eariler.) As you'll see in "A Sincere Form of Flattery" (page 106) I finally decided to devote a whole chapter to recognizing certain painters who've served as inspiration for some of my photopaintings. Some of these works could be considered tongue-in-cheek, but there is also a more serious side. Nothing should prevent you from paying tribute to a favorite artist. After all, if that artist served to stimulate your appreciation of the arts, why not show that respect? I recall, for example, my first moments at the Metropolitan Museum of Art in New York when I walked into the Impressionists area and saw my first Degas. I honestly experienced a chill, a sublime feeling of profound

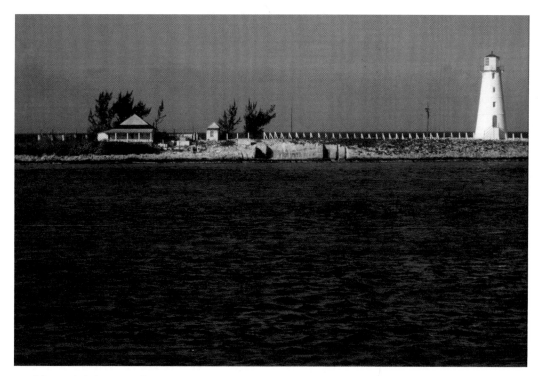

Caribbean Lighthouse, color print

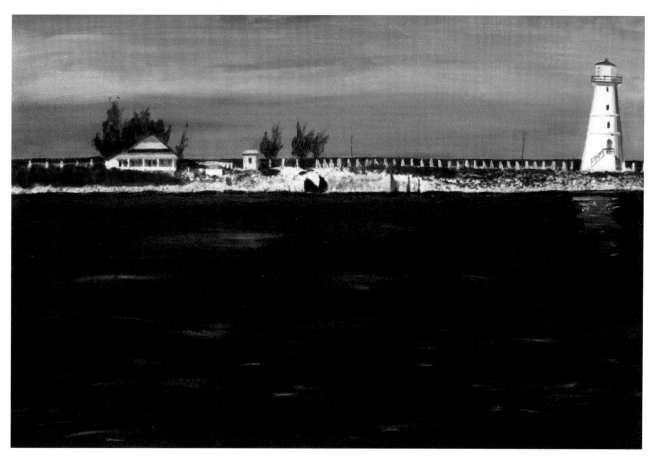

Caribbean Lighthouse, photopainting

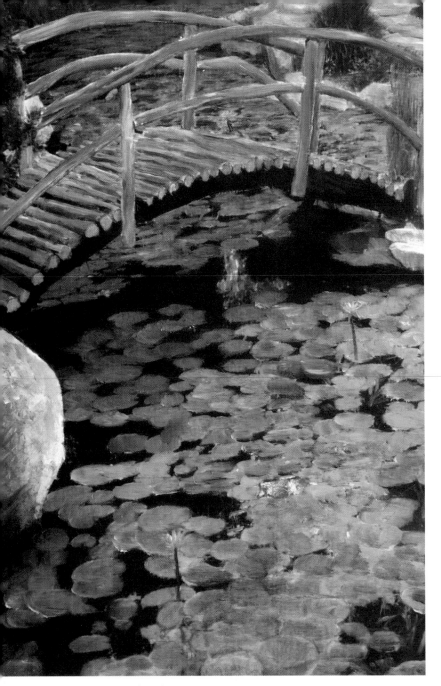

Lily Pond and Bridge

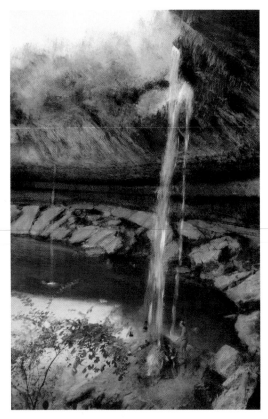

Hamilton Pool

appreciation for what I was witnessing. *Lily Pond and Bridge* was of course inspired by Monet.

Sometimes we don't have to travel too far to find subjects to photograph. *Hamilton Pool* is a great natural formation near Austin that is very popular most of the year. It was a challenge to photopaint, but I wanted to illustrate a wide variety of subject matter and styles, to serve as examples to those who might enjoy taking a

try at their own favorite recreational activities. (See pages 63–65 for a step-by-step demonstration of *Hamilton Pool.*)

Once on a drive around the Olympic Peninsula, my wife and I came upon this sunset tableau at Scenic Lake. I took one shot and left. But I can treasure it as often as I wish, in another water-themed photopainting, *Green Boat, Red Oar.*

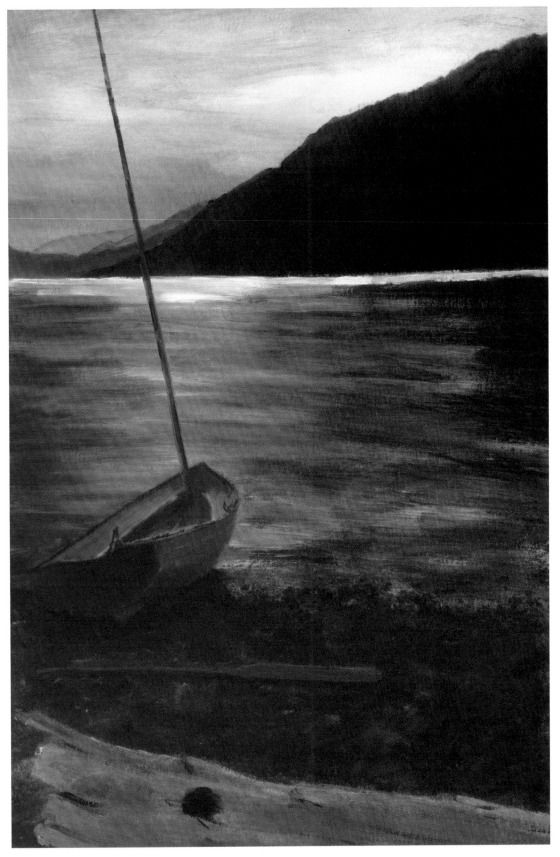

Green Boat, Red Oar

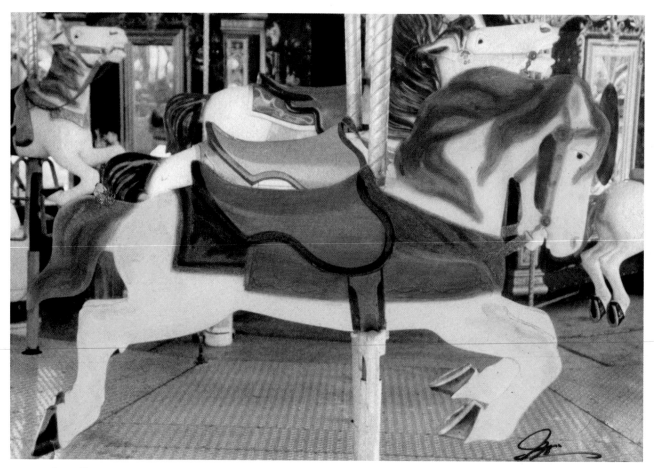

Horse of a Different Color

Dark Horse

Carousels offer a great opportunity for discovering photopainting subjects. I always find myself over-shooting and wind up with dozens of images that go unworked because I have yet to create a "carousel" port-folio. *Horse of a Different Color* and *Dark Horse* both show variations of photopaintings that leave a portion of the photographic image unaffected. (See page 59 for a step-by-step demonstration of *Dark Horse*.)

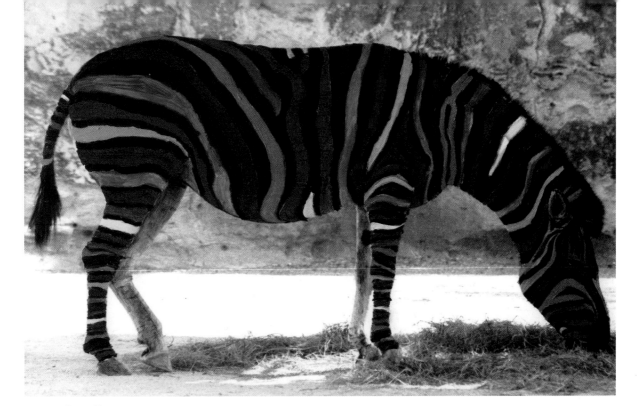

Horse of a Different Stripe

In a similar vein, how could I resist a zebra? I turned a similar rendition of *Horse of a Different Stripe* into a T-shirt as a gift for a friend who insisted on it. (See page 57 for a step-by-step demonstration of *Horse of a Different Stripe*.) I am still looking to have my camera with me when I "spot" a dalmatian, but I did manage to turn my paintbrush loose on a spotted Appaloosa horse in *Ol' Paint.*

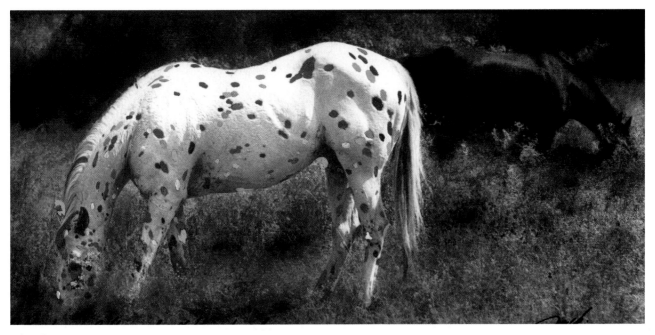

Ol' Paint

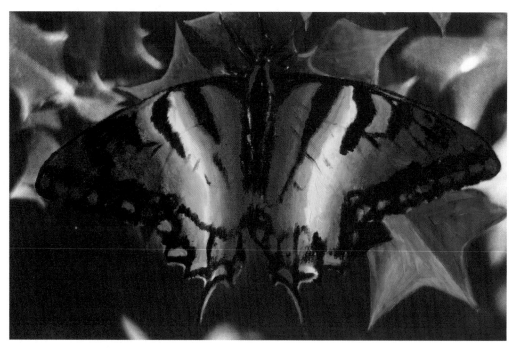

Jim's Amazing Technicolor Butterfly

A Passel of Pink Flamingos

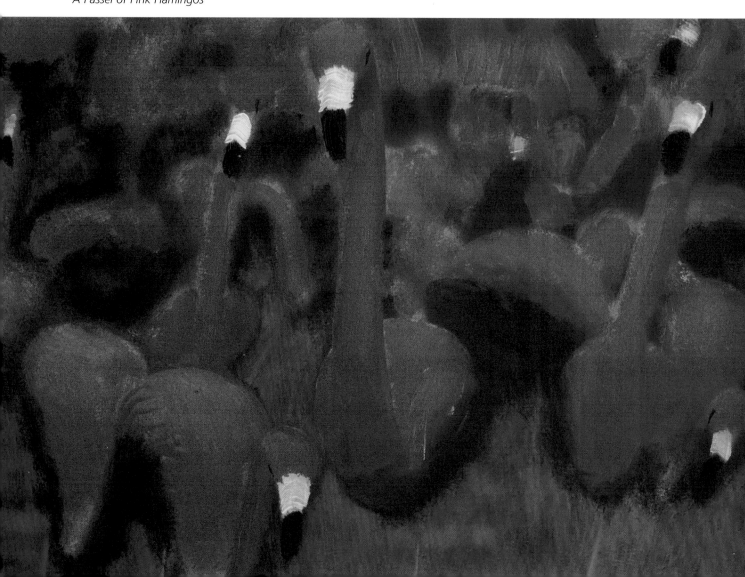

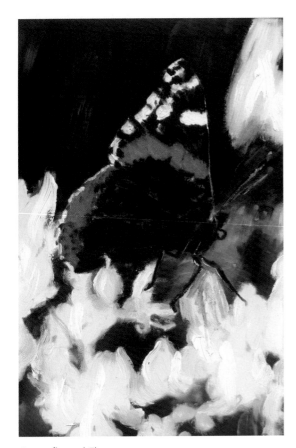

Butterfly and Flowers

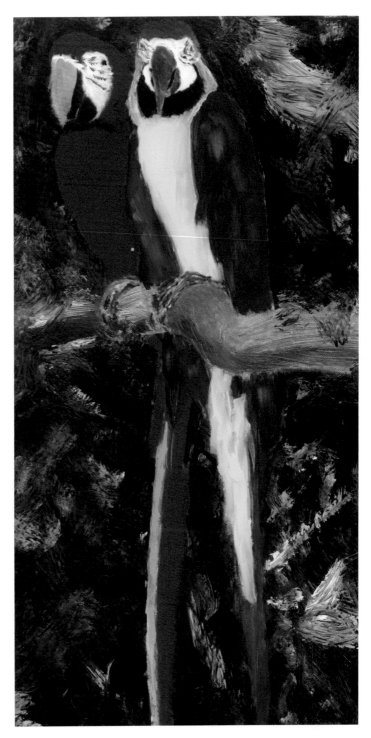

Brothers Macaw

When searching for subject matter, it might be something close to your heart, as in my wife's case (and now mine), the joy and beauty of wildlife. Even though it is not an improvement on nature, you don't have to restrict yourself. Don't be afraid to add your own touch, as in *Jim's Amazing Technicolor Butterfly,* or to react to the bizarre displays of others, as in *A Passel of Pink Flamingos.* Not everything has to be part of a search for universal truths—do what moves you! (See pages 89–91 for a step-by-step demonstration of *Butterfly and Flowers* and pages 92–94 for *Brothers Macaw.*

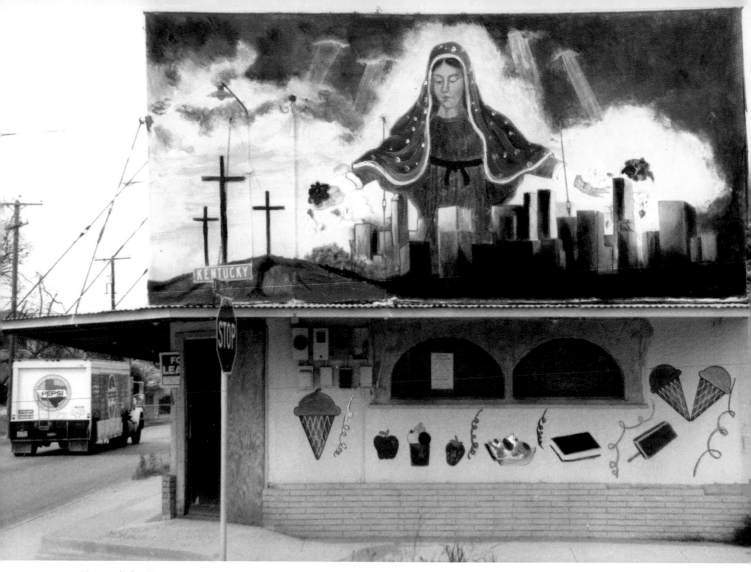

Virgen de las Raspas

Simon and Garfunkel sang that the words of the prophets are written on the subway walls, and so too are the images of artists sometimes found on barrio murals. *Virgen De Las Raspas* perches serenely atop an abandoned ice cream stand.

Sometimes you turn a corner and something catches your eye. Often, when I do that, it becomes a photo-painting, as it did *White Picket Fence* and *Lucky Dogs.*

By now I'm beginning to feel a bit like a certain short-haired novitiate skipping around the Alps singing, "These are a few of my favorite things." Nonetheless, I want this tour to demonstrate to you that the pictures you choose to work with should be your own decision. Some you might consider "art," while others are simply personal favorites. You're out to satisfy yourself, first and foremost.

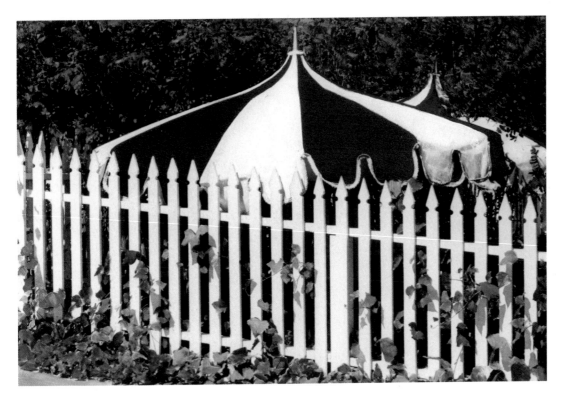

White Picket Fence

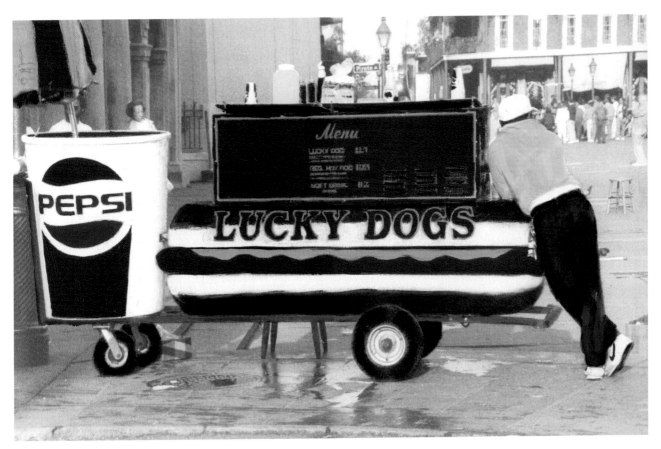

Lucky Dogs

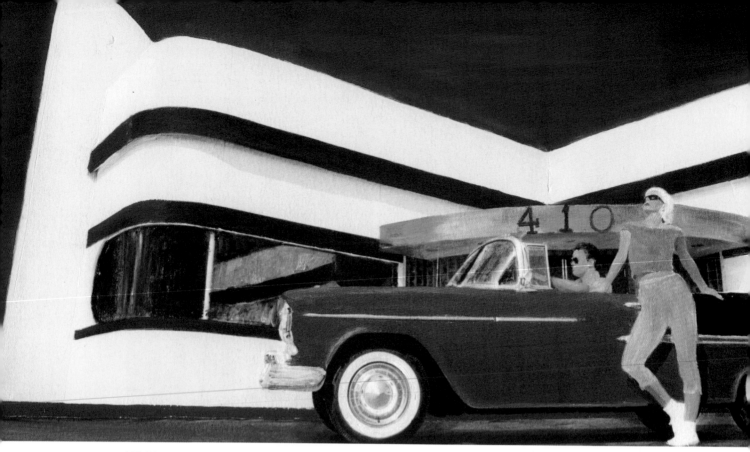

410 Diner

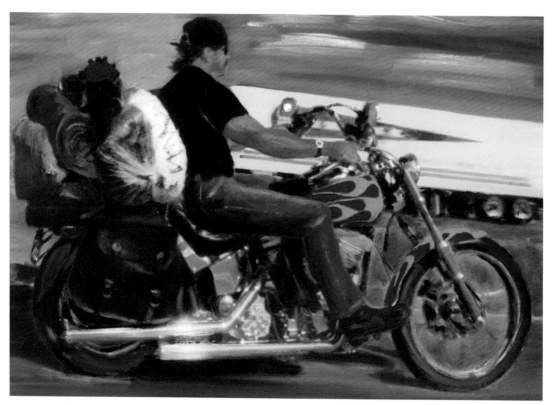

Open Road

Miami Nice

Hey! If you can't find truth (and today Diogenes would have a heck of a search in D.C. or on Madison Avenue), manufacture it! I knew 410 was a new diner, but it had a kind of "authentic" look, so we hired a Fifty-Five BelAire convertible and took ourselves back in time thirty years that morning for *410 Diner*.

Driving down a highway and seeing an American legend, I had no need to invent the truth for *Open Road*—I just embellished it a bit.

As you're well aware by now, I have an affinity for old cars. The one in *Miami Nice* was just another thing that simply "caught my eye."

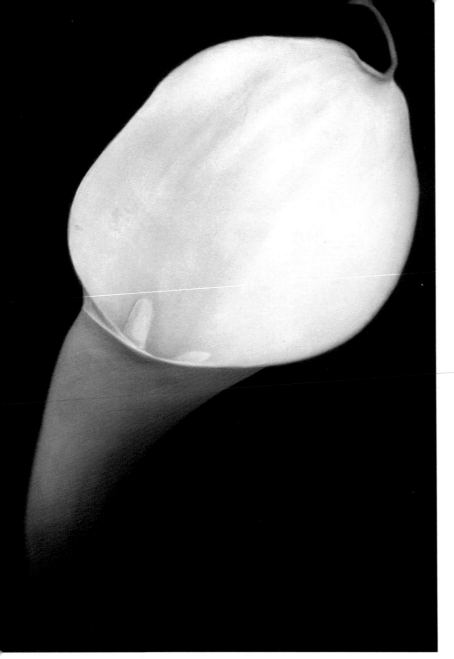

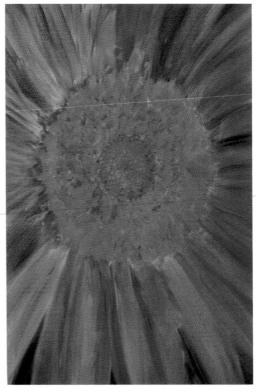

Zinnia

Calla Lily

If your passion is flowers, you know that their inherent grace, tremendous variety, and ready availability make them excellent subjects. With minimal color or detail, *Calla Lily* makes a dramatic statement. *Zinnia,* by contrast, is bold and bright, a closeup so tight the image is almost abstract. *Mother's Roses* appeared as a very subtly tinted picture in *Handcoloring Photographs,* but here the colors are greatly intensified. (See pages 79–81 for a step-by-step demonstration of *Stargazer Lily.*)

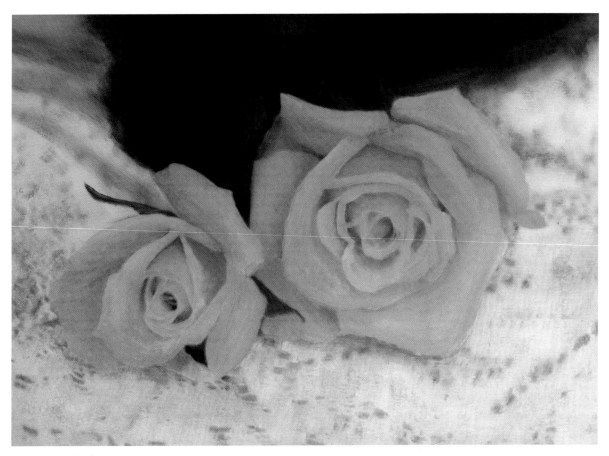

Mother's Roses

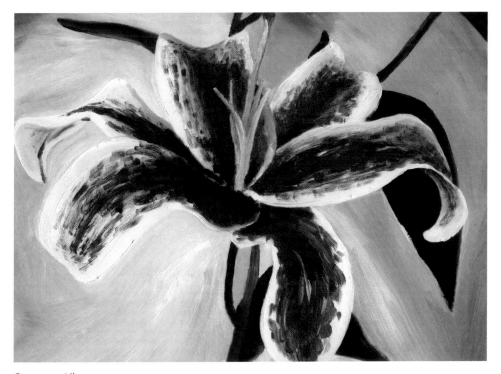

Stargazer Lily

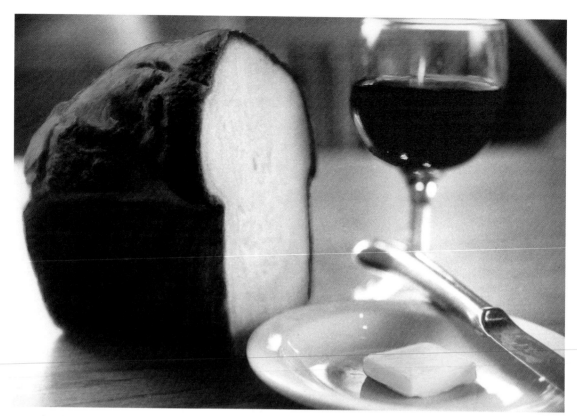

Bread and Wine

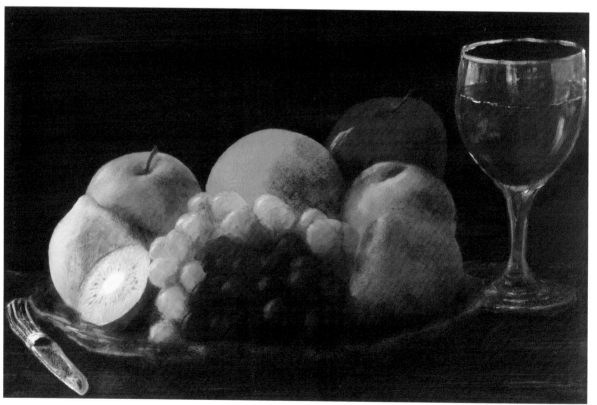

Fruit and Wine

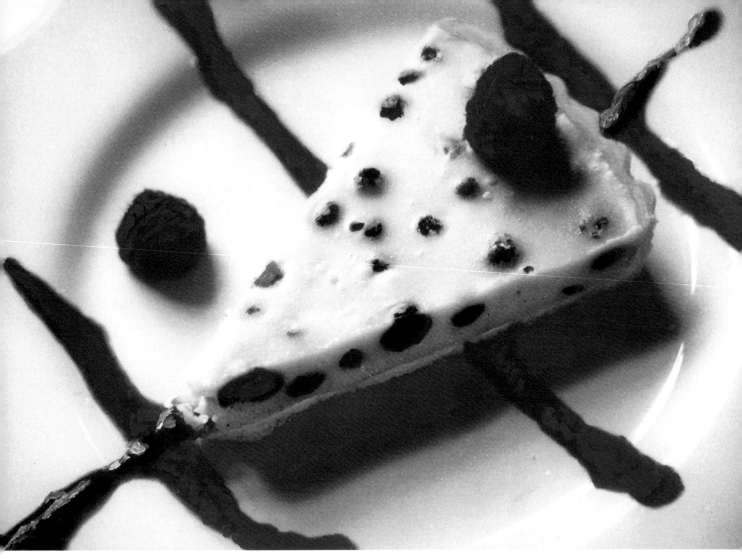

Patriotic Tart

Traditional still lifes can make a fine starting point for a photopainting subject, but, like *Bread and Wine* and *Fruit and Wine*, naturally they look anything but traditional when they're done. (See pages 76–78 for a step-by-step demonstration of *Fruit and Wine*.) Arrangements of food can be particularly fun to paint with intense color. I couldn't resist using the bright, somewhat unreal, yet very patriotic, red, white, and blue colors in *Patriotic Tart*.

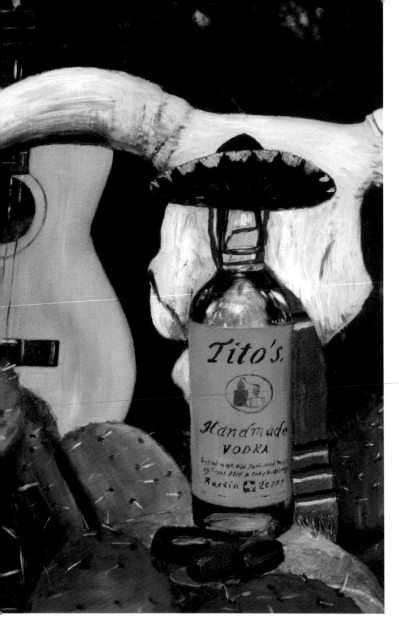

Tito's Texas Vodka

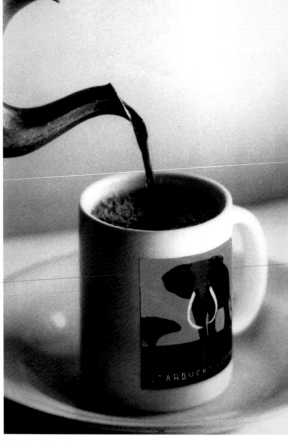

Coffee Break

You might like a friend's product so much that you dream up an idea for him, in this case, a real classically distilled Texas vodka that I honored in *Tito's Texas Vodka*.

But don't forget to celebrate at least a few of your favorite pleasures in your photopaintings. Some of mine revolve around coffee and iced tea, as in *Coffee Break* and *T and Beach Ball*. Then, of course, there's always good ole' baseball, as portrayed in *Ball and Glove*.

I hope that I have accomplished some of the things I set out to do with this tour. Certainly I wanted to illustrate a number of my pictures to show you what photopaintings can look like and I also wanted you to see how many subjects you can consider photopainting yourself. In other words, experiment, see how the photopainting compares to your original photograph, and make changes if you wish. As you've probably gathered by now, there are few rules here. This is the funhouse! Get ready to enter now.

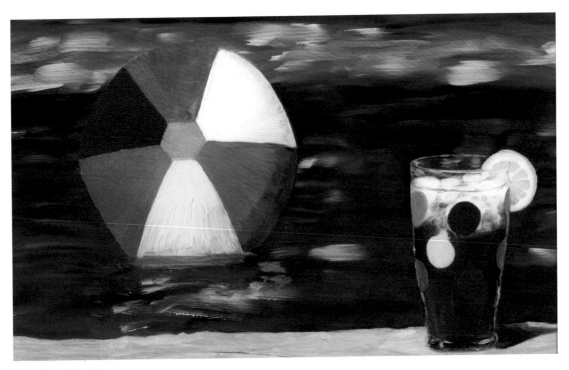

T and Beach Ball

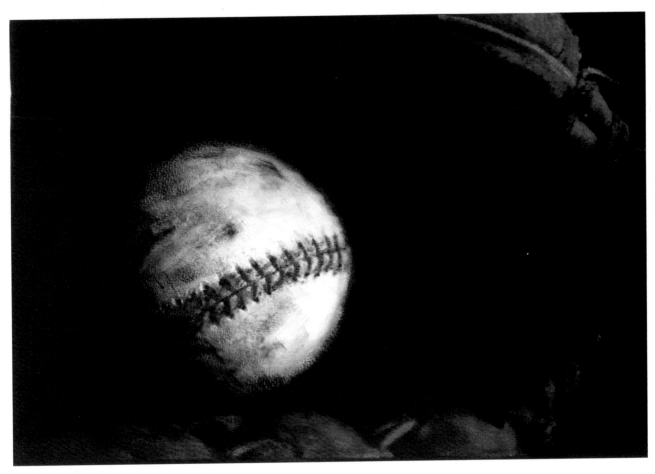

Ball and Glove

Materials and Workspace: The Preliminaries

O ne logical starting point for someone beginning to explore photopainting is learning about the various materials and choosing the ones that work best for you. In this case, photographic enlarging paper, artist oils, brushes, and other application tools as well as several useful ancillary items are foremost on the agenda. In the following sections I will explore these materials in some depth, explaining why I prefer certain brands and types for the specific effects I am trying to achieve. I will also offer some pointers on setting up a workspace for photopainting.

Papers

As a preface to photographic enlarging papers, there are some thoughts from my earlier book that are important. My central thesis in the relationship of handcoloring success to photo papers was that paper selection essentially determined to a great degree the range of effects one could obtain in the tint range. Texture and absorbency of the paper were the two most important criteria. To extend that thesis into the subject of photopainting, the choice of paper remains important for versatility, yet because of the different method of applying the medium to the image, it has a different relationship. If one chooses to retain the maximum versatility in working a print, combining tinting with photopainting, for example, then the same papers recommended earlier, as well as others which have become available since should still be the paper chosen. (My preferences then as now include the following fiber papers: Luminos Classic Charcoal first and foremost, Agfa Multigrade Classic 118, Kodak Ektalure G, and the Ilford matte papers. Among the new papers I have found encouraging are the new Luminos Flexicon and Bergger Prestige Mat. The Bergger paper was highly recommended by my sister-in-law, who is an accomplished photographer, and I found it excellent.) Yet photopainting, to a much more substantial degree than handtinting, can be accomplished quite successfully on papers virtually impossible to handtint, particularly glossy surfaces.

OPPOSITE:
Caribbean Sunset

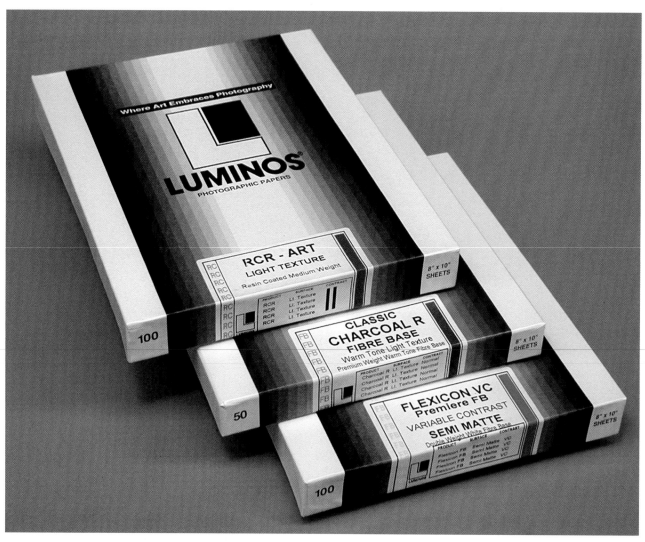

Luminos papers

At this point there are still a number of fine black-and-white photographic enlarging papers on the market. However, as with most products, the bottom line becomes a critical factor in whether the paper will remain available. There are those doomsayers who feel that digital will eliminate film within the decade (and there are those who feel California will someday fall into the Pacific, so buy oceanfront property in Arizona). Dinosaurs were once feeling pretty smug, too, so I am a fence-sitter. I do feel that a number of products will disappear and there will be some significant adjustments in the near future, yet there will still be good products available for photopainting, just as they will survive for traditional photographic purposes.

That being said, my favorite papers are produced by Luminos, a New York–based company. Their traditional black-and-white fine art fiber-base papers are as good as one can obtain anywhere, period. Most fine art photographers who work in black and white consider fiber papers superior for photographic prints. The photosensitive emulsion is on the paper itself. The chemicals used in the developing process soak into the paper and require substantial washing periods, submerged in running water for as long as an hour, to wash away the chemicals that would otherwise stain the print over time.

Foremost among the Luminos papers, the heavyweight Classic Charcoal Warm Tone excels. However, I have recently found three newer papers that I consider

outstanding as well. For the greatest versatility in tinting as well as photopainting, Flexicon FB Semi Matte Warm Tone Base has become my personal favorite. On the other hand, for classic black-and-white tones with the same versatility, Flexicon FB Semi Matte fills the need. In addition, Flexicon FB Glossy makes a brilliant black-and-white print, which gives less versatility to handtinting but would be a great backdrop for limited photopainting. What makes these Flexicon papers even more exciting is that they are variable-contrast papers, allowing you to increase or decrease contrast in the print as you desire.

RC (or resin-coated) papers require about one-tenth the washing time after the print is developed. The resin coating is intended to prevent the photo chemicals from soaking into the paper itself; in that respect they are convenient. Usually, however, this resin coating prevents the surface of the print from absorbing oil color applications, in comparison to fiber papers. In photopainting, this factor is less critical than in hand-tinting. Luminos offers an RC paper that is excellent for photopainting, the RCR-Art paper. Its slightly textured surface permits successful tinting and outstanding pho-topainting, giving the feel of a fiber-base paper while maintaining the convenience of an RC paper.

Besides my favorite Luminos papers, other good papers include Ilford fiber matte surface papers and Agfa fiber Multigrade Classic 118, their numerical designation for matte. I know other artists swear by different papers, including Ilford RC Matte, but I do not find them as versatile as the Luminos papers.

If you have a darkroom and can make your own prints, you obviously have many advantages over the person who needs a photographic laboratory to do the printing. But there is still one big drawback. In many markets, these Luminos papers can be hard to come by. If you have trouble finding them, call their toll-free number (800-431-1859) or visit their website at *www.luminos.com.*

If you must use a photographic lab to make your prints, try to work with one that caters to professional photographers since that type usually offers a wider variety of services. The best situation is to find a lab that will print on whatever paper you request. Some labs will let you supply your own paper and just charge for the service of printing, but this kind of catering to the individual is rare and likely becoming rarer by the hour. Beware the expert at the lab, though, who "knows" the paper they use will work "just as well." I can assure you that is not generally the case. However, there are practical limits as to what one can do.

At the very least, paper selection in photopainting is less critical than in handtinting, as stated earlier. But it is still a factor, and you will learn through practice, experience, and trial and error what serves you best. Once identified, be loyal to that brand. Support it and recommend it to others. The bottom line—reasonable profits—will help assure that the paper remains available.

Paints

Until 1997, I worked exclusively with Marshall Photo-Oils and I still use them for handtinting. However, that year, I had an order for eleven large baseball-related photopaintings, which my gallery had sold to some major league players. Each of these was to be custom painted to order and would be paid for only *after* completion and delivery. It took me a couple of weeks to print and paint the work using my traditional Marshall Photo-Oils and another month or more for the photopaint-ings to dry! This drying time was unacceptable for the way I needed to do business, since my work was done to order. Someone who saw an image in my portfolio and ordered it in a larger size wasn't going to want to wait an extra month or so for the work to dry.

This experience led to my discovery of Winsor & Newton Griffin Alkyd Fast Drying Oil Colours. (Quite a mouthful. For purposes of expediency, I will refer to them as "alkyds" in most of the text.) Essentially they are artists' oils that require only a day or so rather than weeks to dry. For my purposes, they solved a major problem while maintaining the same quality of photo-painting I required. I was able, for example, to fill a

last-minute request from a client on December 22: on Christmas Eve he picked up his photopainting at my studio, done to order and already dry, so he could give it to his son for Christmas. I cannot overstate my satisfaction with this product for photopainting. The Winsor & Newton Griffin Alkyds Fast Drying Oil Colours are in a league by themselves. They are available in most larger art supply stores, or check out their website at *www.winsornewton.com.*

The Winsor & Newton alkyds offer a wide range of colors, and I do use some unmixed directly from the tube, especially the warmer colors such as the Cadmium reds, Vermilion, Cadmium Orange, and the various yellows. But it's often necessary to mix your own colors. With the greens and blues, I generally find myself lightening the hue with either Titanium White or Mixing White. I prefer the Titanium White as a primary white because I can use it alone or mix it for various effects.

Unless you have an unlimited budget and don't mind throwing excess artists oils into the trash, be careful when mixing colors. Make notes as you go along so you'll know how to re-create the colors that you want to use again, and be sure to record the ratios so you don't waste paint trying to match a previous shade. For example, maybe you've already mixed a good amount of a 1:1 ratio of Cobalt Blue to Titanium White, only to realize that you used a 5:1 ratio last time, so now you have to add a lot more blue and the final quantity is about three times what you need, resulting in a lot of thrown-out paint. For the same reason, it's

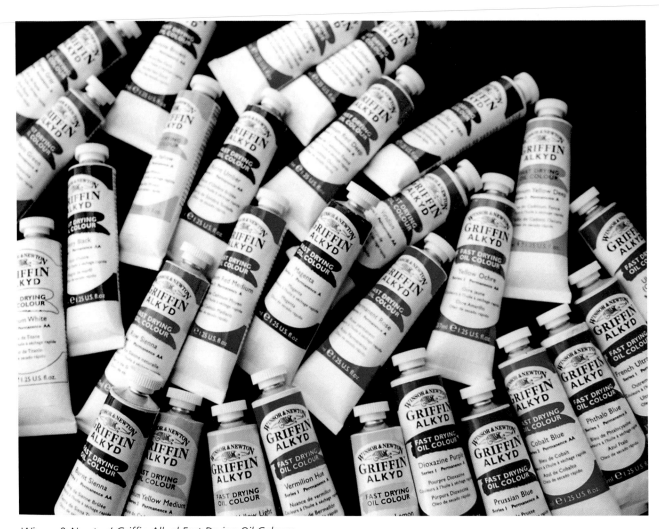

Winsor & Newton' Griffin Alkyd Fast Drying Oil Colours

I bought squares of blue Plexiglas in bulk from a plastics supply store, thinking they would make great reusable palettes, but I soon discovered that it was too messy to remove the leftover paint residue.

I decided that a throwaway palette would be much more practical than one that needed cleaning each time, so I now use scraps of clean mat board instead.

best to use smaller rather than larger amounts when you squeeze the paint from the tube. It's not recommended to try forcing the paint back into the tube—although, if you know just how to squeeze on the sides at the bottom of the tube, *sometimes* you can create a vacuum that will suck some of the oil back into the tube. However, this is not a foolproof solution and can result in even more being squeezed out.

The exception to this "less is best" rule is when you want to have a uniform hue across a large area. In that case, mix well and thoroughly, otherwise a little pocket of Titanium White will affect a considerable change in the uniformity of your application. I find it effective to squeeze two dabs in close proximity for any situation in which you are going to "shape" or gradually lighten an application. For example, the sky is not uniformly blue, but lightens and darkens according to its angle to the sun. Hence two dabs, one of Phthalo Blue and the other of Titanium White, will allow you to vary the shading

from darker nearer the pure blue to lighter adjacent to the unmixed white. These suggestions become self-apparent as you proceed to gain your own experience with the medium.

Mixing for purposes of achieving colors beyond the range of the standard palette depends a lot on individual preference. When you look at a stand of trees, for example, you see such a subtle and variegated range of light to deep greens, some with yellow casts, others cooler, that it becomes a personal choice what you wish to achieve with color selection. Some very general hints are Cadmium Red Deep and Vandyke Brown for burgundy; Phthalo Blue and Phthalo Green with White for turquoise; Prussian Blue and Payne's Gray for navy blue; Magenta and White for lavender; Rose and White for pink; and Phthalo Green and a yellow, either Cadmium Light or Medium or Winsor Lemon, for a brighter green. For more on color mixing, see Chapter Three (page 55).

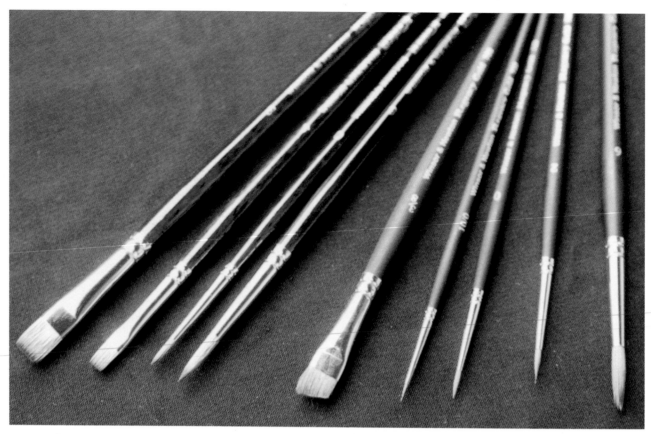

Notice in this selection of brushes that one has a slanted edge. I find this brush as useful as other flat ones and perhaps a bit more accurate for handling an apex or other angle between flat areas. However, I have used only one of this kind of brush and am not quite certain whether its enhanced utility is due to its angle or the fact that it has a slightly softer tip than the other flat ones.

Brushes

When I discussed the application of colors to the photograph in *Handcoloring Photographs,* I was quite adamant about the use of cotton swabs and cotton balls. Photopainting relies on both, but to a far lesser extent. Artists' brushes become the tool of choice and anyone who has gone to an art supply store knows the bewildering variety that assaults the eye in the paintbrush aisle. Winsor & Newton offers an excellent, extensive selection of artists' brushes.

A number of factors should be kept in mind when selecting brushes. In general, for example, it is probably best to avoid brushes labeled for watercolor. Usually the better brushes are identified by category, including artists' oils, so that is where to begin. There is also no rule against seeking help from a knowledgeable salesperson. If asked, simply indicate you are painting with artists' oils—they might look at you strangely if you say you are looking for brushes for photopainting.

Let's concentrate on the tip of the brush first. It might be sable, synthetic, or harder hog bristle, for example. Softer tips are better for blending and harder for heavier applications of color. You should have both available for different effects. You don't want to be using a brush that leaves the application with streaking or bare "valleys" that uncover the base print, unless that is the effect you desire.

Another important feature of the brush is the shape and size of the tip. Point sizes are gaged with numerical designations, ranging upward from 0 for larger points, and for extremely fine points, adding zeroes. But rather than going into great detail about specific designations,

I will describe what the brushes look like and which I prefer for different applications. My favorite brushes are the ones with a pointed tip. For fine lines and working into corners and tight areas, I use this kind of brush most often. I recommend avoiding brushes with tips so soft they seem to collapse when you apply any pressure to the end. Although you don't want brushes that cut through the print, you also want them to have enough strength to hold shape as you apply the color. You might also wish to add a few larger, pointed brushes (sizes 4 to 6) with harder bristles for dry-brush applications. You will find that this technique (see page 55), while effective and useful in creating interesting results, is hard on the brush.

Brushes with a flat edge are good for straight lines, such as a roofline against the sky. They seem to provide a "hard edge" line better than other brushes I have tried. The larger of these are also very useful for applying paint over larger areas.

There are also other somewhat more exotic tips that have never attracted me even out of curiosity since I want the brush to carry its weight; I don't need any slackers. I prefer to invest in a variety of tip sizes rather than tip shapes. Since I use the pointed brushes for detail work as well as general color application, my preference is to have a range from the small, precise tips (sizes 0 to 000), which resemble "spotting" brushes, up the line to rather large ones (sizes 7 to 8 and beyond).

Try to be careful with your brushes, especially the pointed ones, because you want to maintain the integrity of the point and the general brush shape. When a brush does lose its shape, keep it around anyway for applications requiring precision or rougher handling, such as dry-brushing. The most common form of brush mishandling is improper cleaning. After removing as much of the paint as possible with a solvent, sometimes I shampoo the brush in a jar of slightly diluted shampoo, especially if I am putting them up after the session is concluded. Never leave your brushes in the solvent jar indefinitely as you use other brushes, particularly the fragile smaller-pointed brushes. It takes reminding yourself, and a little extra time, but letting them rest on the fragile point for any period of time is a punishable form of brush abuse. Obviously, you should always store brushes tip up; *never* store them resting on the tips.

My choice of solvent for cleaning brushes usually depends on how much I have to spend. Since I am always tight, I usually buy a store-brand lacquer thinner, turpentine, or other solvent that seems price competitive. You may want to look for the term "odorless" on the label, by the way; my wife certainly prefers this type.

Other Materials

Artists' pencils do not get much front-line action in photopainting. Nonetheless, it is good to have some on hand, such as for very intricate detail work. Sometimes you can "clean" an area—in other words, remove an unwanted paint application, such as for a highlight—by using a white pencil carefully. Pencils can also be used effectively to outline areas where you want to paint. This is especially useful for borders that might otherwise be obscured by being tonally similar in the photograph. Since you will be painting over the line, you might want to choose a pencil color similar to the paint you are going to apply, as long as it is still different enough to be visible.

It is helpful to apply Scotch-brand drafting tape to the borders of the photograph before beginning to paint it. This serves two purposes. If you want the photograph to have a surrounding border, the tape masks off this border area. Even more importantly, the tape serves to anchor the print to your working surface, whether that's an easel, a board, or a large Plexiglas panel. This is critical to prevent the photo from slipping when you are patiently trying to apply a particularly painstaking detail. The tape is also useful when working with fiber prints, which have a tendency to curl somewhat around the edges upon drying; the tape will help keep them flat. Also, by anchoring the print to a larger surface, you have more working area and thus it's easier to keep your other hand, wrists, and arms from coming into contact with the painted area.

Artists' pencils are not used often in photopainting but they can be useful for certain tasks, such as detail work or outlining.

In *Handcoloring Photographs,* I recommended the Faber Castell Peel-Off Magic Rub eraser for removing color when fine-tuning certain areas of the photographs (such as highlights, or areas that did not primarily require any color). With the heavier applications of paints in photopainting, this product is less essential, but you should still have one on hand. One of my primary uses is when paint seeps under the drafting tape surrounding the painted area: it's easier to remove the paint with the eraser after the paint dries. A pencil-shaped typewriter eraser can also be useful, as long as you remember that it is somewhat gritty and abrasive, so don't press down too harshly or "overerase" an area. When using either kind of eraser you'll also need canned air to blow the erasure particles off the print. If you try to brush them away, you may streak or otherwise damage the painted surface.

An alternative means of removing unwanted paint from an area is to use Marshall's Marlene solution, which works quite well when you want to remove all the paint from an area. One feature that makes it more attractive than an oily solvent is that it evaporates quite efficiently, leaving no unwanted residue on the print. It is best used by first rubbing away as much excess color as possible with either a cotton swab or a cotton ball. It is also more effective while the paint is still wet. In some cases, it may need to be applied a second time for best removal. One drawback is that you have to work carefully along painted borders because the solution will "feather" the removal area somewhat rather than giving a crisp line. All in all, though, it is good to have some on hand.

As stated earlier, cotton swabs and cotton balls have largely been relegated to second-line duty in pho-

topainting. However, if you want to create a photo-painting that incoporates a tinted portion, the old rules apply. In brief, that means you should apply the tint with cotton swabs, rub the color down with cotton balls, and, above all, complete your tint before beginning the photopainting portion of the work. That said, my primary use for cotton swabs and cotton balls nowadays is to remove unwanted paint from a surface. This includes not only border areas but also those places where you feel unsatisfied with an application. You can use a cotton swab or cotton ball to correct the situation by removing the unsatisfactorily painted area.

Keep a few precautions in mind when using cotton swabs or cotton balls for paint removal. Above all, remove carefully and particularly along a juncture or border with an adjacent area you do not wish to change. In addition, try to "bunch" the cotton ball or swab to tighten any loose fibers because they are inclined to

find their way onto the painted surfaces as lint, which makes for its own headache. Trying to remove a small particle of lint tests the limits of patience and ingenuity and there are no hard and fast solutions. Sometimes I can successfully snag the offending particle with a toothpick, though not always. Always try to use the cotton balls or swabs when the paint is fresh, especially with Winsor & Newton alkyds, which begin setting rather quickly. Never try to rub a cotton ball over an area an hour or more after painting it, unless you want to leave a nice collection of lint behind.

The Workspace

Finally there are some logical considerations for setting up your workspace. As much as possible, try to establish lighting that is shadowless and nonglaring, and

Laying out your colors before you begin working will save time and aggravation later, so you won't have to search for that hidden tube of raw sienna you suddenly need.

Again, the paints are conveniently laid out. All the supplies are kept away from the immediate painting area.

Now you know the final resting place of souvenir cups: they make perfect containers for pencils and brushes.

especially try to avoid shadow in the area you are painting. If you are right-handed, this means that a light source to your left will reduce that prospect, and obviously vice versa for left-handed painters. Attempt to figure out your "paths" of reach, so that you will reduce the odds of snagging something or causing a spill. This is particularly important with your solvent—place it above and to the right of your painting area if you are right-handed, and keep it far enough away so you don't accidentally strike it while reaching for something else. Same goes for your coffee or iced tea. And make absolutely sure not to place your beverage in close proximity to your solvent solution, so you don't accidentally wind up dropping your brush into your coffee or, even worse, swigging your paint thinner. In fact, it is best to have your drinks on a separate platform if possible. I speak from experience: coffee stains do not come out of photographs.

In the first example of the work area (page 51), the palette rests to the right of the print. I will likely hold it with my left hand or attempt to set it above and out of

For this lengthy image, I moved the workspace outside used a door as a work table. As always, the supplies are well away from the potential path of destruction.

reach of either arm, which might otherwise drag across it the painting while I am concentrating on something else. I lined up the colors I planned to use on the photopainting to make them more accessible. The painting is completely taped to a piece of mat board, which in turn is secured to the table. Occasionally I tape the print directly to the work surface, but I generally prefer to tape it to mat board or unscarred Plexiglas. This allows me to adjust the position of the print without having to change my position at the table. But do be careful that shifting the board does not cause you to knock your materials off the table or spill something onto your print.

The second setting (page 52) also shows the work area with the appropriate paints lined up, along with several other supplies. The cup with the Detroit Tigers logo hosts my brushes, not my iced tea, which is on another table. The radio is also placed well away from the immediate work area. In the illustration above, you see I have had to go outside on the back deck because I am working on a six-foot-long multi-image sequence. I

placed a hollow-core door on the table to extend the platform. I taped the photo to a piece of Masonite so I could move it back and forth as I work on the large image. Notice that my solvent container is raised up and away from any critical path to brushes or paints. Here, though, you see a more realistic jumble of thirty Winsor & Newton tubes more resembling a nest of baby snakes than an orderly line-up of marching soldiers. There are two brush cups and another for pencils. The white rectangle of mat board below and to the left of the paints is the palette. My towel for drying brushes is usually draped over the back of the stool and out of the way. *Remember:* exercise care as you take your brush from the solvent; let the excess solvent drip off before you withdraw the brush and bring it over the print to towel off.

The last point about the work area is that it should be comfortable since you will usually be working a few hours at a stretch and you want to be focused on the details of your photopainting and on not your aching back.

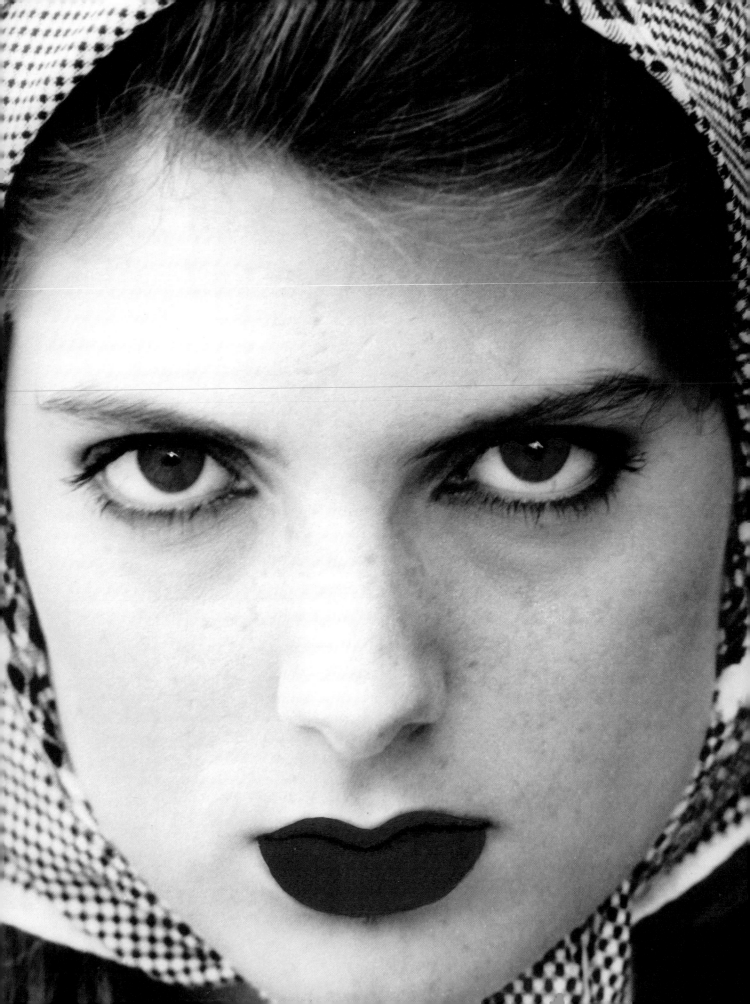

Getting Started: The Process

Handcoloring Photographs demonstrated a basic handcoloring technique that formed the nucleus of my tinting method. Although I showed variations of this process, the basic steps were largely followed even in the variations. Here I have decided on a different approach. Through a series of step-by-step demonstrations I will provide general guidelines for the photopainting process from start to finish.

Highlights and Shadows

When you're working on a photopainting, you respect what the photograph gives you. You do that by being careful. If you make a mistake and feel you're losing it, wipe it up. The blending of light and shadow requires practice and patience. One of the most useful materials is the white you add to the primary color; it's your not-so-secret weapon. Titanium White or Mixing White is important for the "shaping" of the subject, to create highlights or brighter areas of the application.

Sometimes, however, you may not want the white highlight to mix with the surrounding color. For example, you may be working with a bright red and don't want a pink highlight. If you see a shift from a lighter red, which might appear natural, to a pink, which does not,

you might wish to apply the highlight as a pure white by allowing the base color to dry for a short while to a tackiness that retards the mixing effect.

Conversely, a deeper shade is required for shadows. For that effect I generally dab on some black (Ivory Black or Lamp Black) or sometimes Payne's Gray. The ratio of the color to black will vary, depending on the shadow effect desired. When you want to obscure all detail in an area of shadow and see no junctures or borders you can use just the black to produce deep shadow. You can also apply a mix of colors, but for the times when the mix might not look natural—especially if you don't want any of the underlying color as part of the dark shadow—allow the initial color to dry for an hour or so and then apply the black lightly, starting in the deep shadows and working gradually toward the lighter areas. I recommend a "dry brush" technique for this, which allows you build up your shadows gradually. To use the dry brush technique, take a small amount of black onto the brush and then either push the brush against a dry area of the palette or towel off the excess with a cloth.

OPPOSITE:
Green Eyes, Red Lips (See page 56 for demonstration.)

Simple Beginnings

I will begin the demonstrations by illustrating the simplest approach, the selectively painted photopainting. Although this approach is the most basic, it is by no means the least popular or successful; in fact, some people like this look best. The demonstrations will then progress through more complex applications so you can build your technique gradually and can compare and contrast among the various photopaintings as you proceed. Each demo includes the original black-and-white photo so you can see what I began from.

DEMONSTRATION 1: GREEN EYES, RED LIPS

I had worked with Natasha when she was a preteen, then a number of years later I had the pleasure of working with this lovely young model anew for a spring break poster promotion. I was delighted to discover how pleasant she remained, unaffected by the focus on her beauty. With that in mind, and observing that she resembles Ingrid Bergman, I decided to photograph her with a scarf covering her hair, so the emphasis is entirely on her face.

1. I chose to "play" with the photograph, converting it to a photopainting with a minimalist approach. I began with an 8x12-inch image printed on 11x14-inch Luminos Flexicon Glossy paper. I think this particular paper produces the best cool-tone black-and-white image and I knew that the glossy surface would not retard the limited color application. Using Phthalo Green with a slight addition of Titanium White, I carefully add color to her eyes with a small pointed brush.

2. I mix Cadmium Red Medium and Cadmium Red Dark to create what I think is the mother of all reds. Again using a small pointed brush, I carefully, albeit generously, add the red mix to her lips. I call the final photopainting—what else?— *Green Eyes, Red Lips.* (See page 54 for the completed image.)

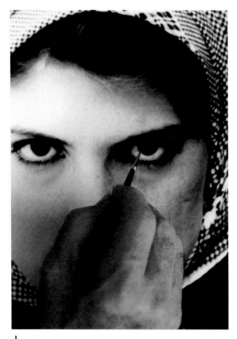

1.

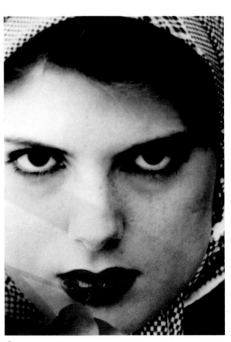

2.

DEMONSTRATION 2: HORSE OF A DIFFERENT STRIPE

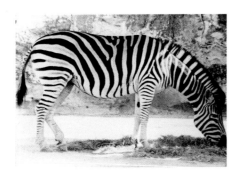

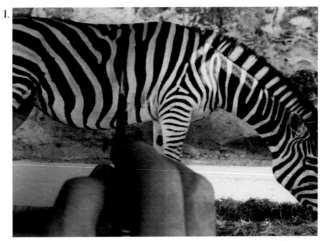

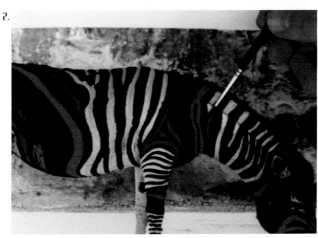

The second photopainting proceeds along the same continuum as the first, a selectively painted image. After doing Ol' Paint *(page 29) in the early 1990s, I had been searching for other black-and-white animals to "change." When I ran across this bored zebra in the San Antonio zoo a few years ago, I knew what I had to do.*

1. I printed the image on Luminos Flexicon Glossy. With a small pointed brush, I first accentuate the black stripes by carefully painting Ivory Black over the existing stripes.

2. I choose twelve colors to add to the lighter stripes in a repeating sequence and mix the necessary colors. Again using a pointed brush for accuracy, I begin painting. In order for the sequence to repeat and to paint all of one color at once, I count off twelve from the first red stripe to the next. Once the repeat is established, I move on to the second color, the third, and so forth. I encounter some difficulties keeping the stripes orderly around the head, but all in all I accomplished what I set out to do.

Completed *Horse of a Different Stripe*

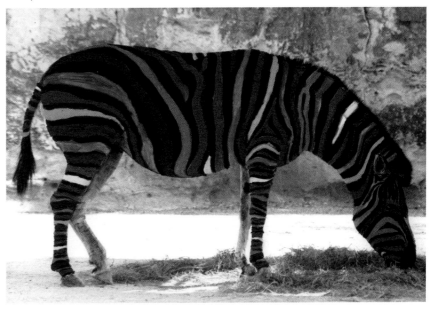

DEMONSTRATION 3: MERRY TEXMAS

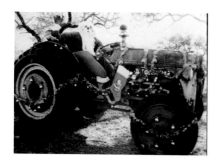

Life is full of roadside attractions, although we are often in such a rush that we miss them. When I moved outside San Antonio proper to a lake area, I found myself passing a Christmas display that always cheered me up. The second season I saw it I made a point to stop and photograph it. But I wound up setting the print aside for several years, realizing that my tinting technique would be stretched to the limit to make it work.

1. On impulse for Christmas 1999, goaded by my wife's annual search for a holiday card and looking for ideas, I stumbled across Ol' St. Nick and his tractor. Armed with my first photopainting success, I immediately saw that there was no need to worry about detailed lines or realism. I set about my task with a small pointed brush, using just red and green. I don't concern myself with much more than adding a heavy pure Cadmium Red Deep to Santa's coat and pants and the stocking hanging near him.

2. I also highlight the ornaments with red, and the big bow on the tractor's radiator. I paint the tinsel garlands green and, within minutes, I have an original and creative interpretation I dub *Merry Texmas*.

1.

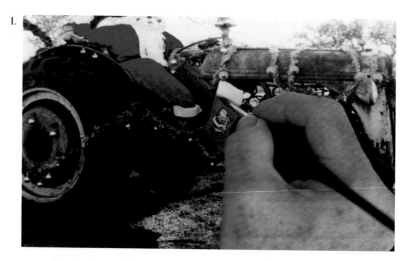

2.

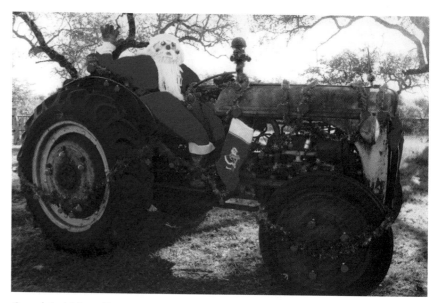

Completed *Merry Texmas*

DEMONSTRATION 4: DARK HORSE

Here's another image that is only partially painted. Carousels are one of the most marvelous sources for images. The photopainting possibilities are limited only by the imagination.

1. In this photopainting, the detail of the horse allows for good illustration of effective shading. Since the areas were large and the shading bold, I choose one of my smaller flat brushes. I must still be careful, though, to refrain from covering an area that needs a lighter shading. I accomplish the lighter application with a higher concentration of Titanium White to Dioxazine Purple.

2. Once the purple application is finished, I begin on the gold, using a mix of White and Raw Sienna and applying it generously to the harness, saddle, shield, and horseshoes. I next apply Cadmium Red Deep to the roses and then to the interior detail within the shield and harness, using a small pointed brush.

3. Finally I complete the work by applying a bright green (Phthalo Green/Winsor Lemon mix) to the leaves surrounding the roses, again with a small pointed brush. The final work, *Dark Horse,* is an impressive, bold photopainting against a black-and-white photo background. (See page 28 for the completed image.)

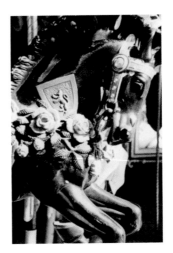

1.

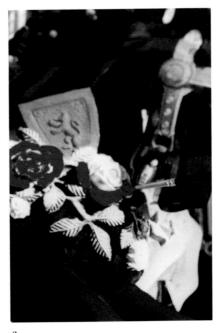

2.

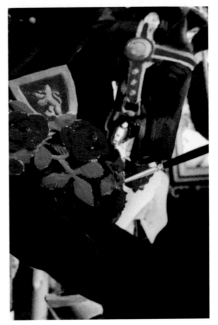

3.

Adding More Color

The first four demonstrations showed you how to pick out precise areas of the print with selective color. The next two exercises cover a little more ground, using paint over more of the image. In my experience, there is no hard and fast rule about where to begin painting first. But if there is an area in which I want great accuracy, I generally start with that. (For example, I wanted to be as accurate as possible with the flesh tones on this page, so I applied the detail work first.) That way, if I need to brace my hand for added steadiness, I am not prevented from doing so by an adjacent painted area. (Also see the final *American Beauty* on pages 2–3.)

DEMONSTRATION 5: AMERICAN BEAUTY

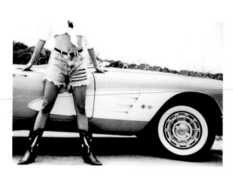

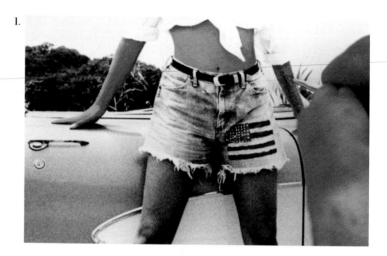

1.

2.

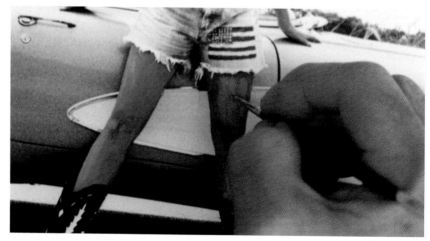

There are few subjects I find more compelling than women and cars. I had a number of excellent images from this shoot, so I chose one I had not used before and printed it full-frame with a black border on Luminos RCR-Art paper, a choice that allows a great deal of versatility in handtinting and photopainting.

1. Since the model was wearing denim cutoffs with a painted-on flag, I decide to keep the red, white, and blue theme. I also decide not to tamper with the less-is-more background. I first add a white application over the white shirt. I then begin with the flesh tones, combining Burnt Sienna with Titanium White and keeping a dollop of Vermilion alongside on the palette. Using a small pointed brush, I carefully work one area at a time, using the white to shape the body parts.

2. I repeat the procedure with the legs, using the same small brush for accuracy of application. Again I carefully dab the "flesh" mix from the palette. I want the application in this photopainting to be as accurate as possible, and stay religiously within the lines, although I certainly don't intend the piece as a work of "realism."

3. I choose the angled flat brush for applying the Cadmium Red Medium/Dark mix that I prefer for the best red. This brush offers a dual advantage in this task. First, it permits me to cover a considerable area while maintaining accuracy along borders. Second, by working it along its flat side and tilting it slightly, it gives me a pointy tip for areas that require careful attention to edges and detail, such as along the chrome, the door handle, and adjacent to the legs and hands. The long white area above the brush is where the highlight for the curve of the fender must be worked in. I will work that up more carefully at the end of the red application.

4. I use a mix of Prussian Blue and Titanium White to achieve the denim effect. I do not "mix" them so much as apply them in sequence, with a higher concentration of blue along the darker areas of the worn cutoffs, and white along the lighter areas. I then blend as it suits my eye. I finish by adding red and royal blue (Phthalo Blue/Titanium White mix) to the boots and the flag. Although the application of colors was detailed and accurate, the overall effect appears far more that of an illustration than of a photograph.

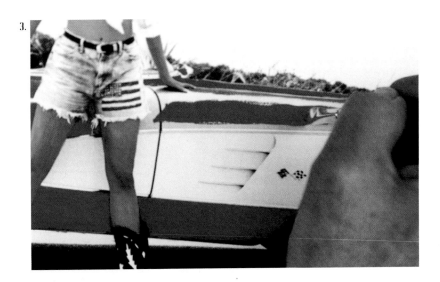

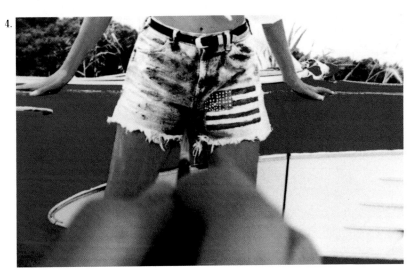

Completed *American Beauty*

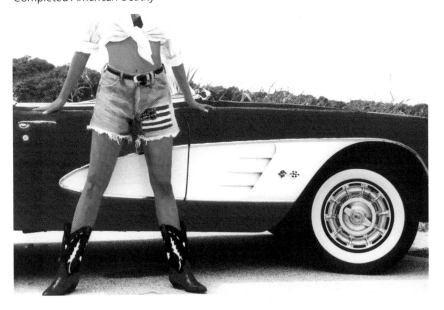

Full-Image Painting

This first "full" photopainting resembles a tint. I call it a photopainting for the technique and effect. It qualifies as a tint because photographic detail is still visible. The technique is "dry-brush" because a minimal amount of artists' oil is used on the brush; color is applied sparingly to the print. Yet the color imparts a texture, and thus it's a photopainting. This technique is perhaps the easiest of those that follow.

DEMONSTRATION 6: THE LAST KAISER IN CLARENDON, TEXAS

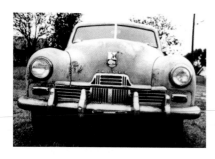

1.

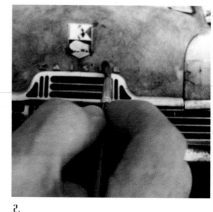

2.

I had originally displayed this image as a black-and-white gallery print and was searching for another interpretation. I printed a black-and-white image on Luminos Flexicon Glossy to try a photopainting version.

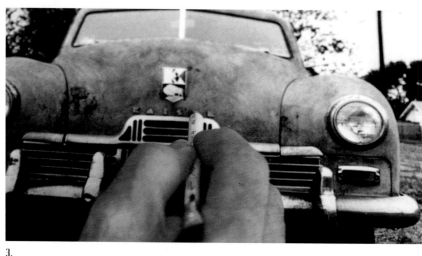

3.

1. I begin with the grass below the car, in deep shadow but visible in other areas of the photograph. I apply Sap Green with a small harder-bristle pointed brush, rotating the brush carefully to keep it only in the areas I want green—the grass and trees. I apply a thin "dry" Ultramarine Blue to the sky, again rotating the brush rather than using long strokes. It's a subtle, almost imperceptible hint of color. Also subtle are the Cadmium Red Medium and Vandyke Brown I apply to the house roofs.

2. With a minimal amount of Raw Umber on the harder-bristled brush, I begin carefully applying color to the car. By rotating the brush and moving it back and forth, more accuracy and control are possible, so there is little overlap into other areas.

3. Once the Raw Umber is applied to my satisfaction, I put a fine point on the abrasive rubber of my typewriter eraser and carefully remove any color from the chrome, lettering, headlights, bumper, and windshield surround. (See page 18 for the completed image of *The Last Kaiser in Clarendon, Texas.*)

DEMONSTRATION 7: HAMILTON POOL

Hamilton Pool, a popular recreation site outside Austin, is sheltered by a cavelike natural limestone formation that shields it from the hot Texas sun. I've chosen this image as a demo for two reasons. First, it's a good straight-forward photo that evokes a mood but is not filled with esoteric significance. Second, it contains enough complexity to provide a challenge, as well as the opportunity to illustrate numerous steps as the photopainting evolves through the tinting process. This is a good jumping-off point for those who wish to try photopainting but are not yet confident about obscuring the entire photograph.

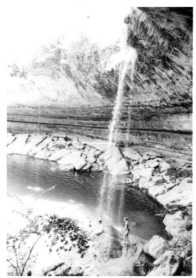
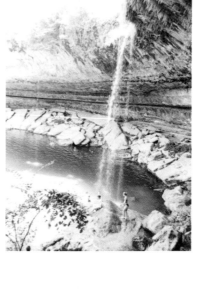

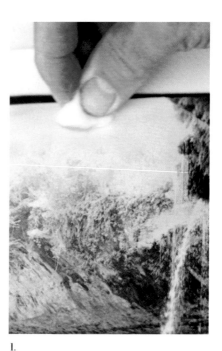

1.

1. I printed the image full-frame on Luminos Classic Charcoal fiber base photographic paper. The very bright late morning sun left a hot spot in the top left corner, so I decide to render the area with a wash of Cadmium Yellow Medium, applying it with a cotton ball and rubbing it down to a faint yellow.

2. With a fairly large, hard-bristle brush, I apply Vandyke Brown in a dry-brush manner, using more paint than I normally would when dry-brushing. (See page 55, Chapter Three for an explanation of the dry-brush technique.) The bristles appear spread out because I'm applying the color in a rough circular motion, not worrying about crossing over into other areas, although I do take more care along the border between the yellow and the brown since I want more

2.

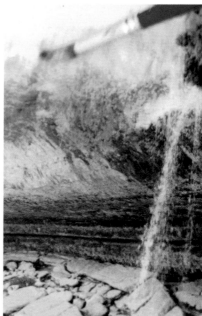

3.

definition there. I then apply Yellow Ocher to the lighter areas and the large stones, and wipe both applications down to more of a tint with a cotton ball.

3. With the same hard-bristle brush I roughly apply a shading of Sap Green along the top of the opening and wherever I note vegetation along the walls.

4. I proceed to add Viridian to the darker water areas. As you can see, the sun creates a hot spot directly behind the small limbs projecting into the frame from the lower left. Once the water is painted the print is almost midway through the process; it now resembles an incomplete "wash" and is more a handtint than a photopainting, yet the basic process is complete where background color has been laid. Details such as the swimmers on the rocks have so far been completely ignored.

5. I now begin the photopainting technique in earnest, reapplying a heavier layer of a mix of Cadmium Yellow Medium and Sap Green to the area at the top of the opening, and applying Sap Green to the hanging ferns in the interior. I apply a layer of Vandyke Brown to intensify portions of the wall and variegate the colors in an abstract, random pattern, then switch to a softer-tip medium-point brush to apply Ivory Black to the deeper shadows.

6. With a flat-tip brush, I apply a Raw Sienna/Titanium White mix to the large rock in the foreground. I have also applied a lighter-hued mix of the same duo to the large rocks surrounding the pool, letting the color rest on the rocks' surface to accentuate them. Notice that I have also reapplied Viridian to the water, here and there blending in a dab of Titanium White for highlights.

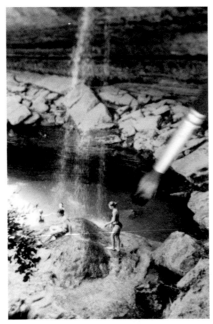

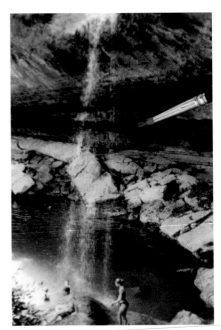

4.

5.

6.

7. The springs that feed the pool form miniature waterfalls, which I highlight with a smaller brush and Titanium White. To emphasize the falls, I add more water (Titanium White) than was actually falling in the photograph. I also add a blended white where they hit the water's surface.

8. For the swimmers I use a mix of Burnt Sienna and White, re-creating their shapes in a general sense for a feeling of realism without becoming too detailed. I will spend more time with the two people on the foreground rock because of their relative importance to the photograph.

9. After putting color on the swimsuits, I add a variegated Sap Green/Phthalo Green/Cadmium Yellow Medium combination to delineate the leaves and limbs in the foreground. I do not mix the three so much as dab from one while leaving a bit of the previous color so that the colors are not uniformly the same. The image is now complete. (See page 26 for the final image.) Notice that enough of the paint application is visible as pure color and texture, while the photographic detail remains evident. A print such as this is an excellent way of establishing more self-confidence about the evolving process.

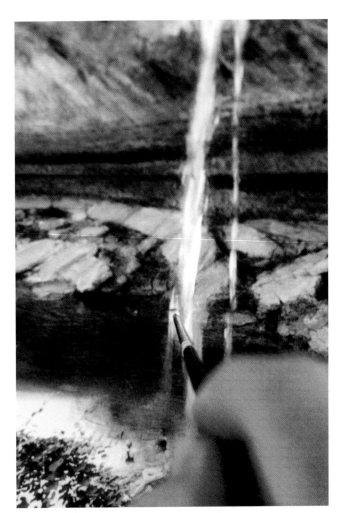

7.

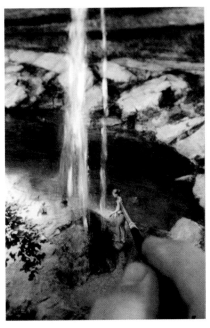

8.

9.

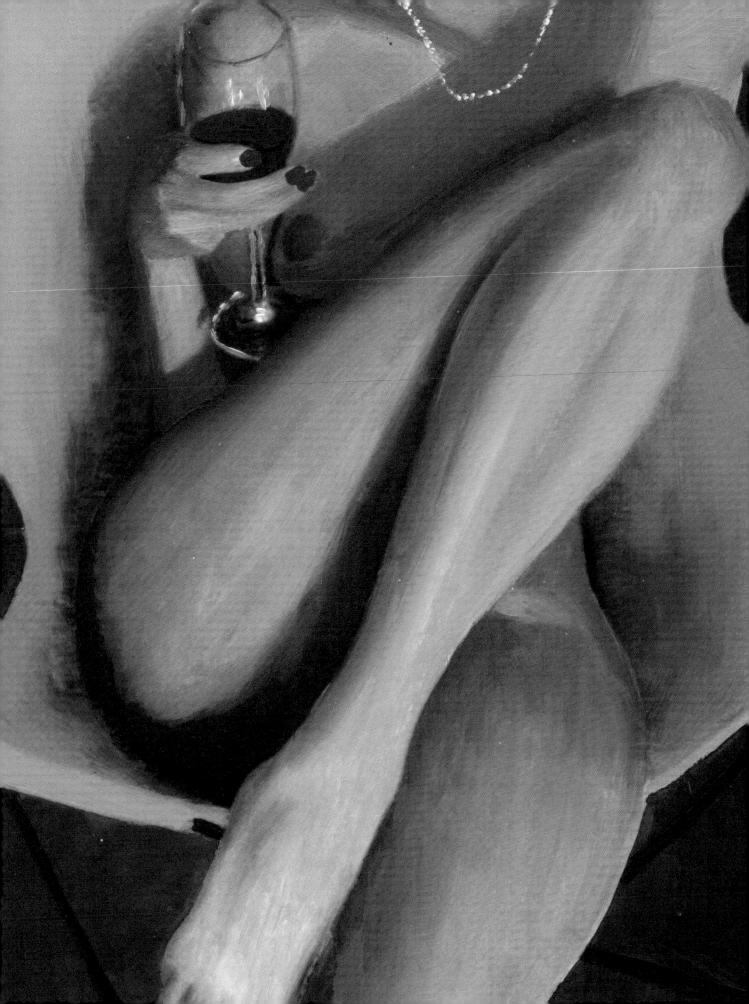

More Techniques: Finessing Your Image

I t's now time to take the training wheels off, dive into the deep end of the pool, grab the controls. I promise you won't fall off, drown, or crash. Come on, I'll show you how easy it is. It only seems hard.

By the end of this chapter you will have observed the photopainting process on a dozen images. A few conclusions about the common points that can be drawn from the individual works will help you find ideas to assist you in facilitating your own photo-painting experience. As I said earlier, I don't feel there is a "basic" technique as there was in my handtinting process. In tinting, it's easier to feel confident working in a more cavalier fashion over large areas, doing a wash, being initially careless with borders, proceeding through the sequences, and yet be reasonably assured the process will yield a satisfactory result.

Remember: Photopaintings are *not* photographs. If you expect them to be, you will likely be disappointed. Photopainting requires a much more cautious, delib-erate approach than handtinting does, largely because you are putting a more generous amount of artists' oils on the print and that application has inherent traps. It mixes and blends far more readily with adjacent appli-cations, and it can be messy, both on the print and on the surrounding areas such as oneself and the imme-diate environment. As I explained in the section about the workspace (see pages 51–53), there are common-sense procedures to minimize a messy, unsatisfactory experience, such as working top to bottom, left to right (if right-handed), and background to foreground. Yet these are not in any way rigid rules. If you are careful and attentive, you are less likely to carelessly place your hand on a portion of the print you just painted.

Also, be sure to watch adjacent areas much more carefully than with handtinting. There you are usually able to "lift" an overlap by applying the second color. If you attempt that in photopainting, you will most likely achieve an unwanted blend of the two, often to your dismay. If you have overlapped, very carefully remove as much of the overlap as possible with a swab or two and take care in the new application.

Determining Painting Sequence

In handtinting, I had an almost universal rule that you worked from larger areas to smaller, general to detail. In fact, I cautioned beginners repeatedly about this because there is a tendency to want to see detail quickly and the process doesn't work that way. Such is not nec-essarily the case with photopainting. As a general starting point, if the detail is the most important factor, begin with that.

OPPOSITE:
Red Wine III (detail) (See pages 72–73 for demonstration.)

Cheryl, tint

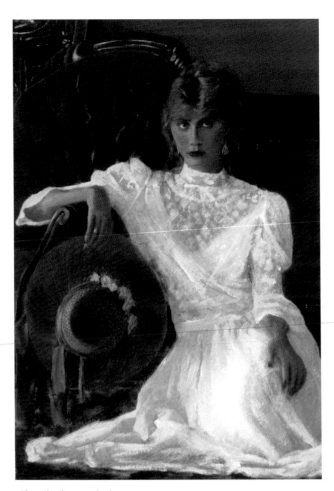

Cheryl, photopainting

An example comes to mind immediately. I was working on *Cheryl,* an image with which I had had great success as a handtinted photograph. I wanted to see this image as a photopainting, and began with high hopes, working the background, top to bottom, concentrating on larger details until I got to her face. Though I knew the painted effect would no longer resemble the tinted image, she had to look like Cheryl! After several unsuccessful attempts to rework it, I finally discarded the piece. However, I needed to know the "truth"—was photopainting such a departure in effect that it would unacceptably transform the individual in an image? I reprinted the image and began again. But, this time I began with the most important details—her eyes, her lips, the shape and shading of her face—slowly, painstakingly following the photograph's nuances.

It worked! I then began to work the other details:

her hair, the background, her dress, the chair, the hat, the carpet. Everything else was secondary to the expression, and the details necessary to capture it needed to be the focus of my work.

A tinted photograph, no matter the manner of the tint, is a colored *photograph.* You expect a departure from a black-and-white photograph—departure likely from a machine-produced color photograph—but you still have a photograph showing through the color application. With a photopainting, depending on the effects, most of the time you will be seeing a photo*painting,* not a photograph. Once you accept the departure point, you may find as I did an almost unbridled amount of pleasure at working up a photopainting from a photograph. If your experience is similar to mine, there will also be a sense of wonder and delight as it unfolds and a satisfaction with what results.

Colorful Details

Two or three years ago I went off in search of boots because I wanted to do a "Texas thing." One of my first images was *Texas One Step*, which gave me total *carte blanche* on color selection. I wanted to explore the image's color potential to the fullest and did so by squeezing almost every available color onto my palette and enthusiastically dabbing paints on the print. My only real concern was to retain some degree of accuracy in "staying between the lines" so that I did not obscure the wonderful subject through carelessness.

DEMONSTRATION 8: TEXAS ONE STEP

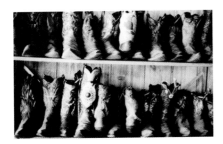

Texas One Step is a real favorite of mine. The black-and-white version is printed on 11x14-inch Luminos Flexicon Matte, an excellent black-and-white fiber photographic paper for tinting as well as photopainting.

1. I set out separate dabs of Burnt Sienna, Vandyke Brown, Titanium White, Ivory Black, and Raw Sienna on the palette. I dip a flat brush carefully into Burnt Sienna, then brown, and a bit of black for the shadows. I paint with an up-and-down stroke to give the illusion of wood, letting the brush marks help suggest wood grain.

2. Without cleaning the brush, I add a bit of the white and highlight the shelf edge and some of the grain in the back.

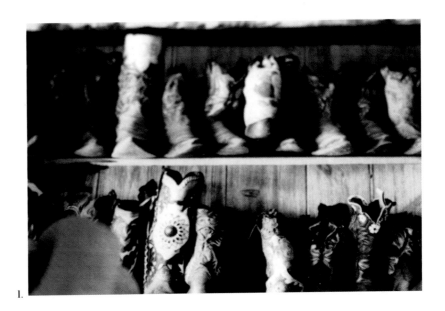

1.

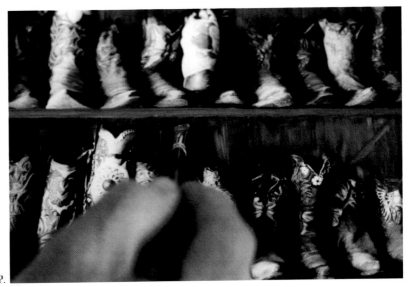

2.

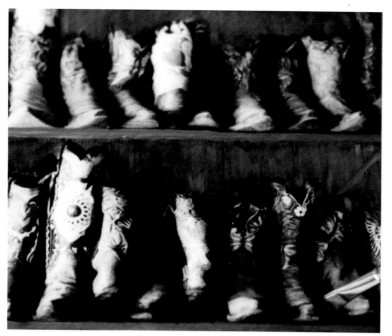

3.

4.

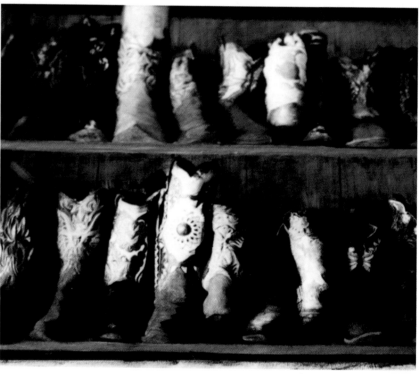

3. Next I work the heavy shadow area between the boots with Ivory Black on the clean flat brush.

4. Once the shelf looks reasonably natural and before I begin on the boots themselves, I wipe off any excess paint with a cotton swab. Then I examine the boots and decide that, with twenty-five individual boots on the shelves, it's best to do an assembly-line process, doing the bottoms first, then the designs. The relative difference in gray tones among the boots gives me a basic idea how to paint them. Essentially, they fall into tan, medium brown, reddish brown, brown, and black "bottoms."

5. I add to my colors already on the palette and set about painting them, left to right, top to bottom, one color at a time. Since each boot appears fairly small, I know that I must be careful, use a small brush, rely on the Titanium White to assist in the

5.

highlights, and not become concerned about every detail. I start with the tan duo, using a mix of Raw Sienna and white. I use a bit more white with the Vandyke Brown

for the medium brown (rawhide) boots, Burnt Sienna for the reddish-brown ones, straight Vandyke Brown for the darker brown bottoms, and Ivory Black for the black boots.

6.

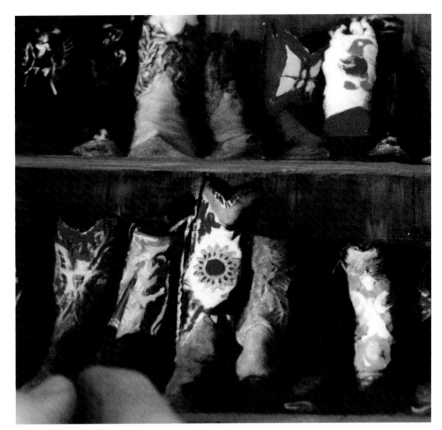

7.

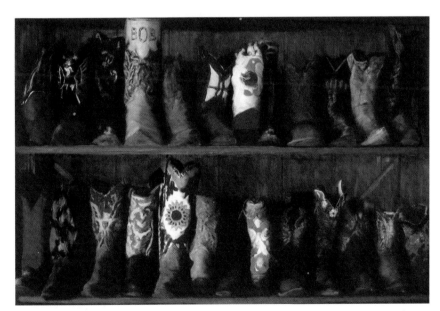

Completed *Texas One Step* (Shown larger on page 11.)

6. For the colored details, once again I organize my palette, selecting a variety of colors and choosing a very small pointed brush for pinpoint control. But I must still be careful to keep any excess paint off the brush so the paint doesn't bead up on the point and accidentally cause a blob on the print. (If this does occur, take your time and rework the area right away.) I paint all the red details first before moving on to another color.

7. As you can see, you needn't agonize over making the detail work so painstakingly accurate that it stops being fun. Remember to pace yourself. And keep in mind that when you work small areas of a photograph carefully, you may find that the print often looks unfinished until very near completion (as it does in step 6). This is less discouraging if you anticipate it, otherwise it can dissuade you from proceeding. This image demonstrates the rewards of patience in the face of highly detailed work.

Capturing Flesh Tones

Although Winsor & Newton does offer a flesh color, I have yet to use it. For the base tones of Caucasian skin, I rely primarily on a mix of Burnt Sienna and Titanium White. To add a pink cast I judiciously add a bit of Vermilion, and for darker shaded areas I primarily use either Burnt Umber or Vandyke Brown. Rarely, and only in the deepest shadow, do I employ black because I have found that any such mix introduces an unrealistic gray cast. Working with the Burnt Sienna and white, and blending according to the lighting on faces, arms, legs, and so on, you will soon develop a sense of how the "roundness" of the features emerges.

For darker-complexioned individuals, try Vandyke Brown mixed with Burnt Sienna as the base, with a judicious addition of white. On black skin, highlights should appear more as reflected light than a gradual lightening toward light brown. Burnt Umber and Raw Umber work better in deep shaded areas for the same darkening for realistic shadows and shaping of features. In some cases, either Raw Sienna or Yellow Ocher is more effective than white shaping skin tones.

When handling flesh tones, try to derive "hints" from surrounding areas. You might begin with the deeper shaded areas, add a mix with more Burnt Sienna, then reapply color to your brush and proceed until you have worked the area to your satisfaction. As long as the paint is still fresh, you can rework it until it is right to your eye.

DEMONSTRATION 9: RED WINE

I chose one of my favorite images as the starting point for "cov'rin' all th' pitcher," as us Texans say. It's relatively straightforward, a discreet nude seated in a canvas chair holding a glass of wine. Yet it provides sufficient room for observing some basic photopainting techniques: shadows emphasize the shapes, providing depth without too much complexity.

1.

1. I begin with the little shaded area of floor behind the chair, choosing a mix of Vandyke Brown and Ivory Black and keeping some of the Ivory Black back unmixed on the palette for later use. Using Cadmium Yellow Deep on a medium-pointed brush, I paint the more-highlighted areas of the chair. Without cleaning off the yellow, I dip the brush into the Ivory Black and paint slowly away from the body, starting in the deepest shadow by her hand. I redip the brush and do another line along the arm and hip, remaining in the deepest shadow. Dipping the brush in the yellow, I begin working and blending

the lightest area of the shadow, letting the photograph guide me. I repeat the process on the other side of the body. For the brightest highlighted area, I add more yellow with a clean small-pointed brush.

2. For the figure itself, I put Burnt Sienna and Titanium White side by side on the palette and mix some of it. It naturally blends into a deeper-shadow flesh tone nearer the sienna and lighter shade nearer the white. Using one of my smallest-pointed brushes, I begin with the hand, blending some Sienna in the shadows and working it smoothly into the lighter areas. I line the shadow between her second and third finger, then go down the forearm, paying careful attention to how the shadow from her leg looks on the arm. Next I mix a little Burnt Umber with a dab of Sienna and work it along the line of the black shadow. For the upper body I choose a slightly bigger pointed brush. Observing how the shadows look, I slowly blend the paints to replicate them. I apply the same principles to the leg, making sure to go carefully. It's important to keep body shaping very subtle and smooth so that the result looks natural. By continuing this process, pretty soon the body is nearly finished.

3. A little Cadmium Red Deep on the smallest-pointed brush takes care of the toenails. For the wine I use of bit of Vandyke Brown and Cadmium Red Deep, then hit the wineglass with some Titanium White for highlights. Next, mixing French Ultramarine Blue with just a bit of Titanium White, I get to work on the carpet with a flat brush,

remembering to paint that little bit behind the chair in the shadow. With a black pencil, I carefully line the chair legs so I can go back over them, and I do the same with the pattern on the carpet. I'm very careful when running the blue along the leg. Finally, with a tiny dab of Ivory Black on a small -pointed brush I go over the pencil line carefully. (See page 66 for the final image.)

2.

3.

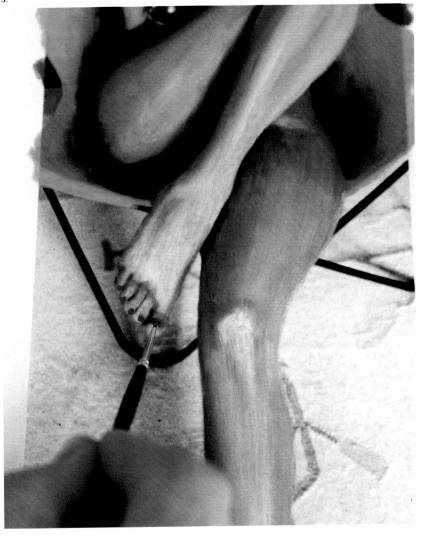

DEMONSTRATION 10: HAT AND BOOTS

More than twenty years ago I took a color slide of this great Seattle roadside attraction, which sadly is no longer there. Note that the step-by-step illustrations in the demonstration are for a slightly different version than the final work shown at the end, but the process is essentially the same. An important aspect of photopainting is that each one is an original and although color matching can come close, there are no restrictions (except self-imposed) about modifying the image in the new work. This print was executed on Luminos RCR-Art photographic paper.

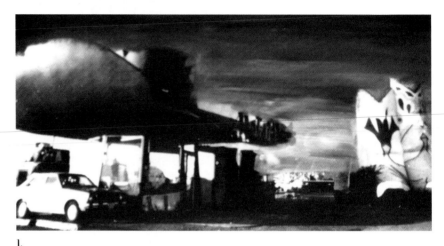

1. The first area to paint was the sky. I choose a blend of Phthalo Blue and Dioxazine Purple with a generous amount of Titanium White. I use a flat angled brush, which lets me cover a large area, while at the same time the soft tip allows for more effective blending. I begin with more intense blue and purple at the top and gradually blend in more of the white as I move down the print. As much as possible, I try not to overlap the paint too much, although I do want long strokes for blending purposes. I remove much of the overlap with a cotton swab before continuing.

1.

2.

2. I clean the brush and use it for the hat, mixing a Brilliant Red with Cadmium Red Medium and Deep. Rather than do an even blend, I use more of the medium in the brighter areas, and more of the deep in the shaded ones.

3. In the heavily shadowed areas, working out from the deepest shadow, I blend in a small amount of Payne's Gray in order to darken the red somewhat without modifying its hue. I use the brush on its edge to feather a darker line for the edge of the brim as it crosses the crown in order to distinguish the two features. With a smaller-pointed brush, I highlight the Hat and Boots sign in red with Cadmium Yellow Deep detail.

4. The sky and hat done to satisfaction, I turn my attention to the boots, which are actually the restrooms. The real ones had pink trim on the women's and light blue on the men's, so I decide to take it further and paint the boots pink and blue with deeper pink and blue trim. For the pink boot, I use a mix of Magenta and Titanium White, with a heavier concentration of Magenta for the trim. I repeat the process for the men's boot, substituting Phthalo Blue for the magenta. I lightly dry-brush Ivory Black into the shadows between the boots and add the hedges around the boots in Sap Green.

5. This image begged for bright colors and I didn't shy away from the task. I painted the wall behind the office a Cadmium Yellow Medium, and finished with a Cadmium Orange for the car, Viridian for the dark trim on the truck in the background, and Cadmium Red trim on the station. I added green doors to the shed to the right of the office. A mix of light and dark Payne's Gray finished the surrounding lot.

Based on the same image, the final version on page 16 utilized a mix of Vermillion and Titanium White for the pink boot with Cadmium Red Deep for the trim, and French Ultramarine Blue with Titanium White for the blue boot. White mixed lightly with Payne's Gray created the shadows on both boot tops. The wall behind the office was painted Cadmium Yellow Medium and the shed door was a mix of Cadmium Red Deep with Vandyke Brown. The hat and sign were

3.

4.

5.

painted with the same colors as in the demonstration. The sky also

used the same colors, but I blended them much more subtly.

Still Lifes and Florals

Still life arrangements and floral subjects offer a wonderful opportunity to work with pure color. They are also a good way to practice effects of highlights and shadows. This fruit platter image appeared in my first book as a subdued handtint; here, as a photopainting, it blazes with color. The picture of the stargazer lily (demonstration on pages 79–81) afforded me a chance to try a very painterly look.

DEMONSTRATION 11: FRUIT AND WINE

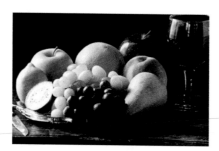

My first attempt at photopainting this image didn't seem to be working—I had been too cavalier in my approach and had used too much paint. So I printed another one, this time on Luminos RCR-Art paper, and set about working it up more carefully. This is an excellent paper if you are in a hurry (as I was) and don't want a fiber print washing for an hour and taking another several to dry.

1. I squeeze out all my colors: Titanium White and Ivory Black; Dioxazine Purple and Ultramarine Blue for the background; Vermilion for the plate; Vandyke Brown and Burnt Sienna for the table; and for the fruit, Cadmium Red Deep and Medium, Cadmium Yellow Deep, Raw Sienna, Sap Green, Magenta, Winsor Lemon, and Raw Umber. I begin with the background, initially painting it deep Dioxazine Purple, lightened with a little Titanium White. Over this I paint Ultramarine

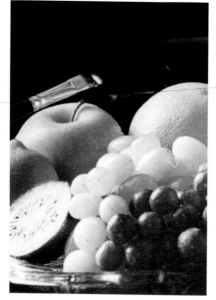

1.

Blue, blending in the white separately while the color remains fresh and thick. I use the largest of my flat brushes because the area is relatively large.

2. Although the brush's wide, flat tip allows more adroitness with borders, the long strokes result in some overlaps, particularly since I am working the Titanium White into the mix broadly. I remove most of the overlaps with a cotton swab, particularly the heavier amounts. I am not too concerned with the slight tint that remains.

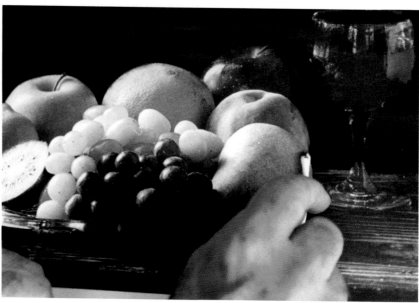

2.

3. Being right-handed, my normal progression across the print is left to right. In this case, however, because the wine glass is higher in the picture, I set about painting it next, choosing one of the larger pointed brushes to better blend the colors and more accurately add highlights to the glass. A combination of Cadmium Red Deep and Vandyke Brown works well for the wine, sometimes varying the effect into deeper burgundy. On the left side of the glass toward the bottom, I add a faint dab of color for the reflection of the fruit, which I purposely did not cover completely in the application of the red/brown mix.

4. The fruit allows me to create some brilliant colors. Instead of subduing the red apple, I paint it the brightest mix of Cadmium Red Deep and Medium, adding a bit more in the brighter area of the apple. I use Cadmium Yellow Deep for both the orange and peach, layering on some red mix for a "peachy" effect on the latter. The pear at bottom right begins with Raw Sienna, which is soon overlaid with more Cadmium Yellow Deep, Titanium White, and red blended in here and there, and the highlights are brightened with white. I use a blend of Sap Green and Titanium White for the green apple. The angled flat brush is helpful here because I must be careful wherever the fruit meets the background.

5. A lighter blend of Sap Green and Titanium White works for the white grapes, while Magenta and Titanium White shapes the red grapes. I use

3.

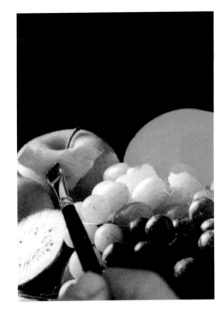

4

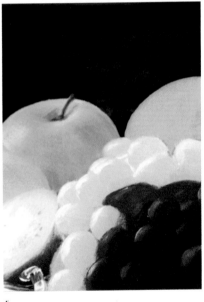

5.

6.

straight Winsor Lemon for the lemon and Sap Green, Raw Sienna, and white for the kiwi. The skin of the kiwi is a mix of Raw Umber and white.

6. Although I want brilliant colors, I haven't achieved sufficient shadow effect. I don't want to blend Ivory Black with the colors since that might create a dulling effect. After allowing

the photopainting to dry an hour or so to tackiness, I carefully apply Ivory Black with the dry-brush technique (see page 55). Using a rather large hard-bristle brush, I take considerable care to work in the deepest shadows, attempting to darken the fruit without painting it black. I want the *effect* of shadow without necessarily working toward true realism.

7. Once finished with the fruit, I turn my attention to the plate. I approximate its antique rose color with Vermilion, using some Titanium White for highlights and a fair amount of dry-brushed Ivory Black for shadow. I then work the knife, adding Ivory Black to the handle and a light shading on the blade. I emphasize the highlight areas of the blade edge and the handle with Titanium White.

8. Finally I can see the finish line, and I begin painting the wooden platform on which the still life rests. Vandyke Brown, Burnt Sienna in the highlight grain and edges, and Ivory Black mixed with brown provides the effect I want. Looking at the final photopainting, I'm satisfied that I've

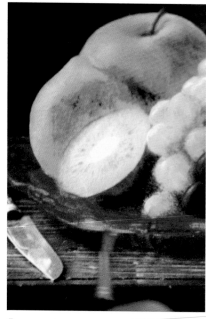

7.

8.

now achieved what I set out to do: create a vivid presentation of the fruit colors while maintaining the

effect of the side lighting with deep shadow. Sometimes it is better to go around twice.

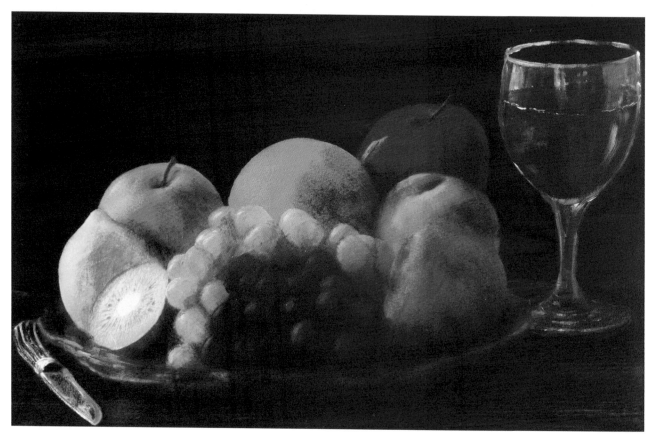

Completed *Fruit and Wine*

DEMONSTRATION 12: STARGAZER LILY

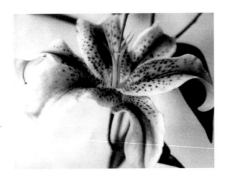

1.

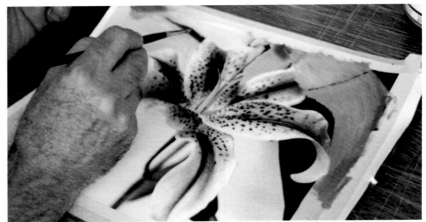

2.

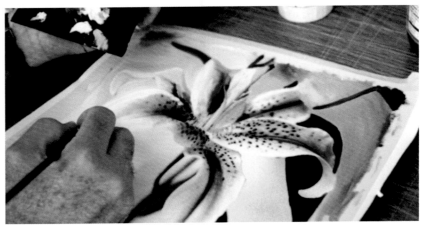

3.

Flowers lend themselves perfectly to photopainting because of their inherent grace, color, and beauty. Recently I spent a few hours at a friend's flower shop taking close-ups of various flowers. For this example, I chose a stargazer lily. The black-and-white image was printed on Luminos Classic Charcoal fiber photographic enlarging paper.

1. Although I am creating a photo-painting, I want to remain faithful to the light and shading and to give a fairly accurate impression of the lily. I begin with the background, applying a blend of Payne's Gray and Titanium White. Observing the background shadows as a guideline, I use a heavier concentration of gray in the heavier shadow, blending it slowly back and forth as the shadow deepens or lightens.

2. Once I finish the top half of the background, I turn my attention to the dark leaves, using Sap Green with adjacent dabs of Titanium White and Ivory Black for blending purposes.

3. Once I've painted the top leaves and stems, I move on to the petals. I place a dab of Raw Sienna alongside the Titanium White so I can infuse the white petal with a subtle warming influence. I also add a dab of Ivory Black so the shaded petal will have a different effect in shadow from the Payne's Gray influence of the background.

4. After painting the top five petals with the warm white, I turn to the dark red areas, using Cadmium Red deep mixed with Vandyke Brown. I also blend in Ivory Black to deepen the shadowed effect on the petal.

5. Once I finish the five petals, I complete the background in the same manner as before, deepening the shadow with Payne's Gray as the photograph dictates. A flat-tipped brush lets me be as accurate as possible where the background meets the leaves, because I don't want any accidental blending of the leaf color with the gray and white mix. Since my strokes are long to facilitate the shadow blending, any unintended green would streak the shading and corrupt the effect.

6. Once I've finished the gray and white application I work on the green leaves and stems. The leaves are mostly dark, so I use Payne's Gray and Ivory Black to emphasize the shadows, then switch to Sap Green for the visibly green portion of the leaves. I give the lower leaf to the left of the unpainted petal a lighter shading to convey light falling on it.

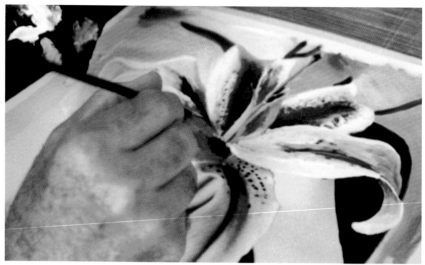

4.

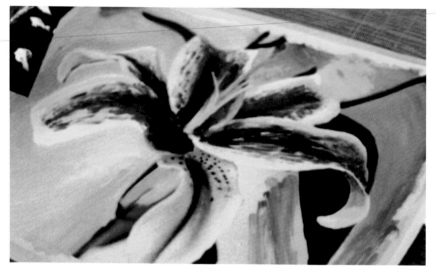

5.

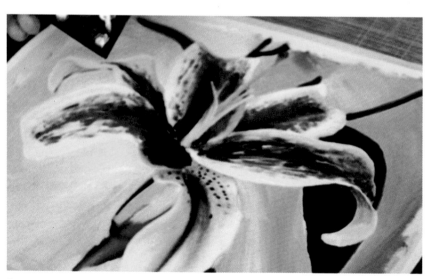

6.

7. The lower petal is now the only item remaining. I have left it for last since it feels like part of the foreground and I want it to feel a bit more emphatic. I begin the petal application anew with a softer, medium-size pointed brush for blending. I want the brightness along the edges to dominate, so I emphasize the whiteness of the application there.

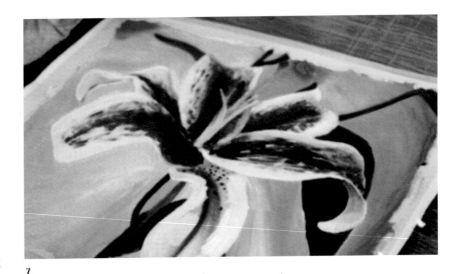

7.

8. I am extra careful when applying the Deep Red to the last petal. In order to keep the petal colors from blending and lightening with the white, I have to apply the red mix heavily so I don't lose the effect. Just as I finish, I notice that the rightmost petal needs a bit of dark red on the underside—luckily I hadn't removed the tape yet.

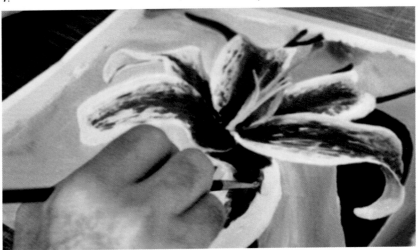

8.

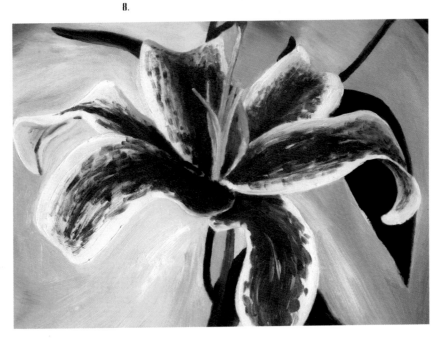

Completed *Stargazer Lily*

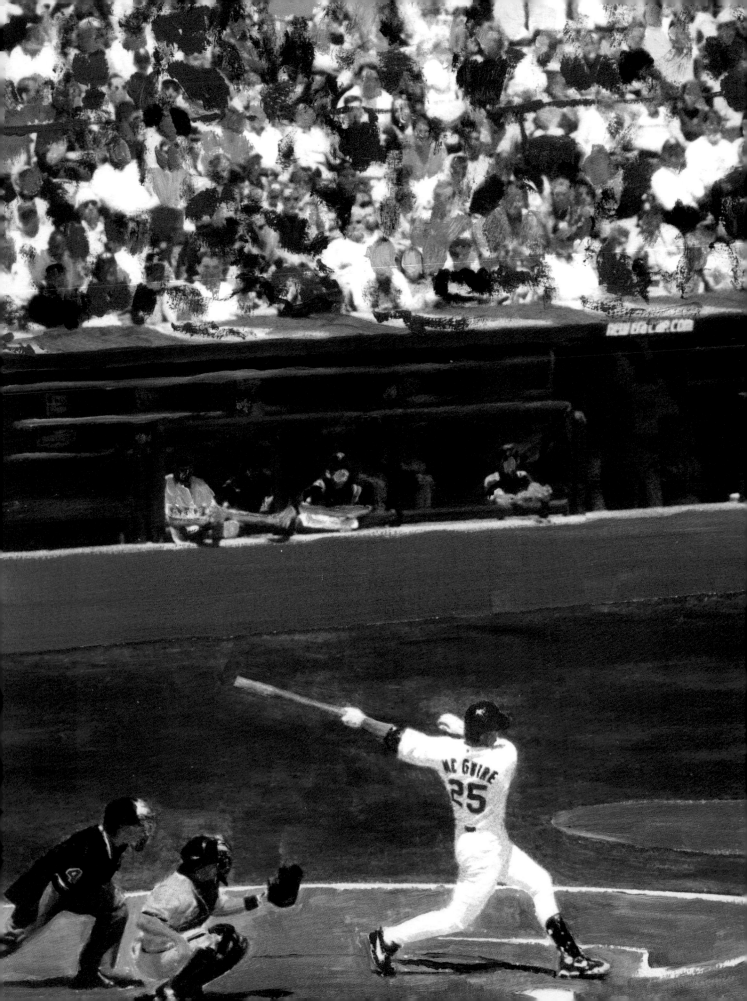

Exploring New Approaches: Letting Your Imagination Reign

B y now you've probably gained a good understanding of general photopainting technique and you may be interested in venturing off on your own. The following demonstrations illustrate some further techniques and variations to help you gain an even surer hand.

Head and Shoulders: Beyond Portraiture

From the very beginning of my handcoloring experimentation over twenty years ago, I felt I was working toward a contemporary technique for a contemporary purpose. I had never liked traditional handcoloring because I found it artificial, particularly in the realm of portraiture. Had a fortune-teller gazed into a crystal ball back in 1975 and predicted that my future would become intimately linked with handcoloring, I would

OPPOSITE:
Mark McGuire #25 (See pages 100–101 for demonstration.)

have laughed heartily and not paid for the session. Traditional tinting sometimes falls into the "retouching" category, and I refuse to link any of my coloring techniques with that category.

Why am I ranting and raving about this in a photopainting book? Because traditional studio offerings tended to be "heavy" oil portraits, which were essentially painted photographs, with tried-and-true techniques for achieving them. I have no objection to whatever direction another person takes with the lessons learned herein, but I do not want to give the impression that because I am illustrating a "head and shoulders" study, I am attempting to illustrate a heavy oil portrait in the traditional sense. I do not intend in any way to infringe on their style or impugn their work; I am simply stating categorically that this is not the purpose of the photopainting that follows.

DEMONSTRATION 13: STACI

The black-and-white image of this very attractive young woman was printed on Luminos Flexicon Warm Tone Matte. As you can see, it is a straightforward image with gentle, shadowless light and a dark background of leaves and vines.

1. I achieve the desired flesh tone with a combination of Burnt Sienna and Mixing White, laying out the two colors adjacent on the palette and partially mixing between them. This way, if I want a lighter tone, I dip the brush from the white side; for darker I work from the sienna side. Nearby I place some Burnt Umber for deep shadows and some Vermilion for punching up the flesh tone. I begin carefully, making smooth strokes so the shades blend seamlessly and I don't get "lost" by covering detail prematurely. My brush is the angled flat one, both because the slightly softer tip makes for smoother blending and also for the accuracy it provides along border areas.

2. To avoid obscuring important details I use a slightly lighter application in those areas, such as the strands of hair on her forehead. I let the contours of the face provide

1.

the shading information I need, attending to each in sequence. For example, the small lines around her nose must be carefully blended in while retaining their shape, so I add a small line of deeper Burnt Sienna at that point. Then I blend over it to give it a more-natural appearance.

2.

3. As I finish the coloring and shaping of the face, I add some subtle touches. I blend in a minute shading of Dioxazine Purple as eye shadow and a hint of Vermilion on the cheeks. At this point the work looks surreal and very unfinished.

4. Using my finest-detail pointed brush, I line the eyes with Vandyke Brown and use the same color for the lashes and eyebrows. I delicately paint in the irises with a small amount of Viridian. These additions dramatically affect her look.

5. As with the eyes, the lips are a critical detail. I carefully apply Vermilion with my detail brush, watching for the natural highlight of the curvature of the bottom lip.

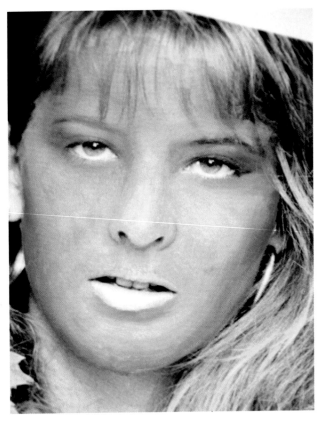

3.

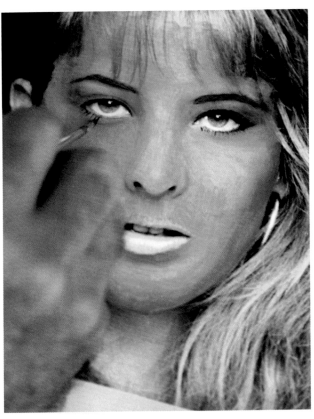

4.

5.

6. 7

6. To work on her neck and the shaded area directly below her face, once again I resort to my angled flat brush. To emphasize the shadow somewhat, I add a small line of Burnt Umber, then begin blending the flesh tones following the contours provided by the photograph.

7. The final flesh application is to complete the ears, which I contour using the flesh mixture, blending lighter and darker as needed through the addition of white or sienna. I'm now ready to begin on her lovely brunette hair.

8. On the palette, I squeeze out a generous amount of Vandyke Brown, lesser amounts of Raw Sienna and Burnt Sienna, and a

8.

miniscule amount of Mixing White. I start by adding the brown to the deepest shadows of the wavy hair,

using the angled flat brush to follow the contour lines provided by the photograph.

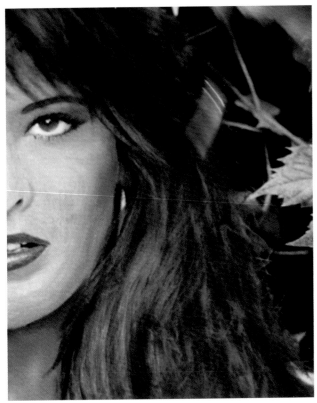

9.

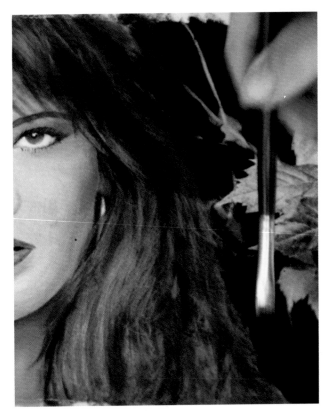

10.

9. I next apply the Raw Sienna and Burnt Sienna in sequence as the photograph dictates. The long strokes allow for effective blending so that the colors mix naturally but still retain enough individual identity to provide a pleasing appearance to the luxuriant hair.

10. With Staci herself painted, I turn my attention to the background. First, I use Ivory Black to deepen the shadows surrounding her hair. Then I squeeze Viridian, Phthalo Green, Sap Green, Cadmium Yellow Medium, and a bit of Mixing White onto my palette to begin on the leaves and vines.

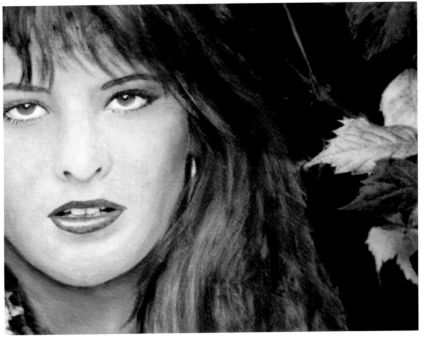

11.

11. The variety of greens will help give a natural, multihued appearance. Look carefully at vegetation and you may be amazed by the variety of color that "tree green" covers. I blend heavy amounts of green into the black shadow to give it a natural camouflage appearance, then I start on the other leaves.

12.

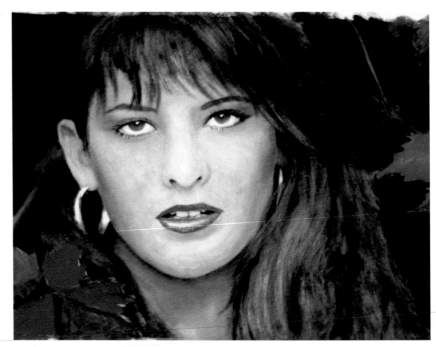

13.

12. For the foreground leaves I add my favorite red, a mix of Cadmium Red Medium and Cadmium Red Deep. To provide a variety of colors for the other leaves I dip into the Vandyke Brown, Burnt Sienna, and Raw Sienna remaining on the palette from the hair coloring.

13. Finally I add gold to her earrings, a combination of Yellow Ocher and Mixing White. I study the work carefully, make any little corrections I feel necessary, and my "head and shoulder" study is complete. Just don't call it a heavy oil portrait and I'll be happy. I think it has far more of a contemporary "illustration" look.

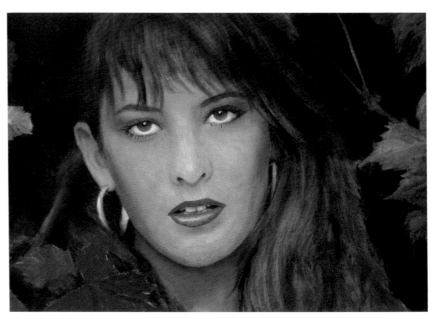

Completed *Staci*

A Loose Approach: Freeing the Hand

My "loose approach" technique uses broader, freer strokes, applying more color in a heavier, more-textured manner. The subject matter is presented with less attention to precise detail, emphasizing color and feeling instead.

Note that "loose" doesn't mean "wild." Think of it as trying to maintain control when a situation threatens to get out of hand. When you're racing down a stairway,

you know that a sudden misstep can mean disaster. Of course, you're not in physical danger when photopainting, but your work might suffer if you become too cavalier. The primary problem is accidentally obscuring important detail. You can always go back and clean up the application, but sometimes that is messy and discouraging. Try instead to maintain a controlled freedom with the paint.

DEMONSTRATION 14: BUTTERFLY AND FLOWERS

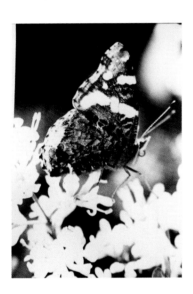

1.　　　　　　　　　　　　2.

When spring was in bloom and the butterflies were in transit to Mexico, I looked over to a tree next door and saw hundreds of them flying from blossom to blossom. I immediately grabbed my camera to get a close-up. I printed a rather rough first print on Luminos RCR-Art paper and decided I would focus on the butterfly and do a loose interpretation of the setting.

1. I begin by darkening the shadows using Ivory Black and a medium flat brush.

2. Next I set out a palette full of Winsor Lemon and a mix of Phthalo Green and Winsor Lemon to do a

loose impression of the blossoms and leaves. I add some strokes of Titanium White, blended slightly, to provide abstract highlights on the yellow. I let the texture of the application carry the illusion of separate petals.

3.

4.

3. With the background finished, I commence on the butterfly. I do have a color print for reference, but since I am planning to be less than photographically detailed in my interpretation, I don't follow it slavishly. I add Ivory Black to the wings, then some Ultramarine Blue to capture the iridescence there.

4. That completed, I add pinpoint-size small dots on the upper wing with magenta, then begin in earnest painting the most dramatic color on the insect.

5. Using Cadmium Orange and a small flat brush, I add color along the area indicated in the photograph, although I may have gone overboard with the amount and intensity.

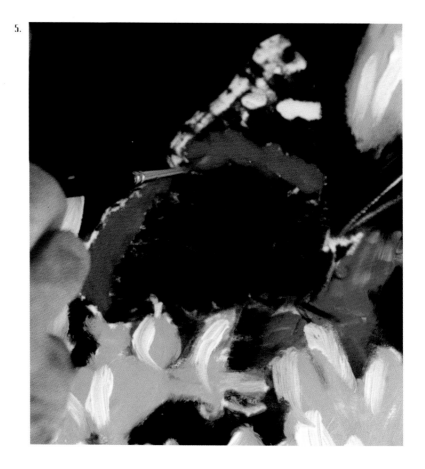

5.

6.

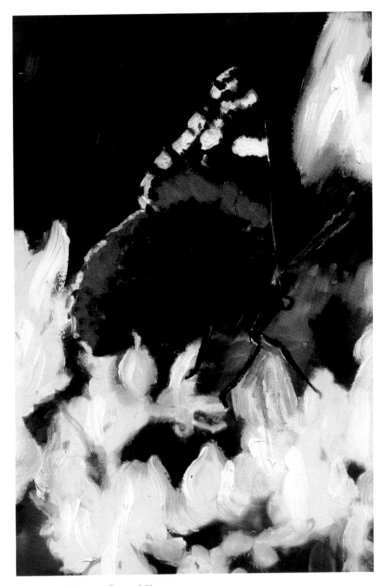

Completed *Butterfly and Flowers*

7.

6. Nonetheless satisfied, I go back to my Ivory Black and add some small dots in the orange. I also pick out the white on the wings.

7. I paint the spindly legs and the antenna with Ivory Black, adding dots of Cadmium Orange around the head and the tips of the antenne.

Trading Places: Transforming the Background

Sometimes you see a great subject with a distracting or unappealing background and you photograph it anyway, knowing you may never print it because of the background. Other times you really have no choice and you make do. But there's a third option—you equip yourself with your trusty photopainting technique, confident that your subject can trade places because you can create a more desirable location.

DEMONSTRATION 15: BROTHERS MACAW

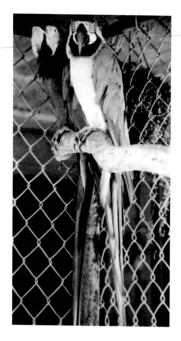

Over the better part of the last ten years, my wife has served as a volunteer at a wildlife rescue sanctuary for injured and displaced animals in the San Antonio area. The animals are in a much safer environment as a result of the concerned efforts of the staff and volunteers, but they may have to reside in cages during rehabilitation. One day I went there to photograph some of the "residents" and saw these two colorful macaws. When I took the picture I figured I'd probably never use it because of the ugly fence in the background, yet in looking for more pictures for this book, I realized it would be interesting to rework the background. The image was printed on Luminos RCR.

1. The first order of business is to obscure the cage with Ivory Black. Using a large hard-bristled brush, I work quickly but try as much as possible to keep the color off the birds.

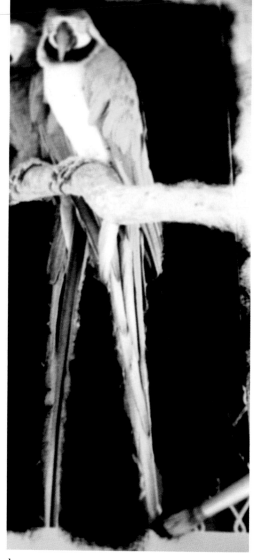

1.

2.

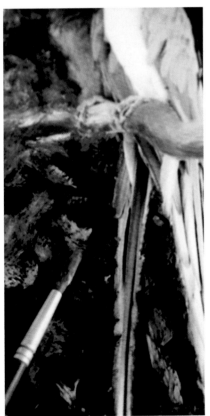

3.

4.

2. I load the palette with some Cadmium Yellow Medium, Viridian, Sap Green, Winsor Lemon, Phthalo Green, Burnt Umber, and Titanium White and set about blending a variety of random forestlike colors into the background. I use a large brush and crisscross strokes.

3. I continue layering tropical-looking foliage into the background. With a mixture of Burnt Umber and Mixing White, I also extend the branch on which they are perched across the remainder of the picture.

4. Utilizing my favorite red mix of Cadmium Red medium and Cadmium Red Deep, I begin on the scarlet macaw. Letting the plumage guide me, I make long, bold strokes using a broad flat-tip brush with heavy color on it. Even though the strokes are rather fast and loose, I manage to paint the bird with little blending into the surrounding colors.

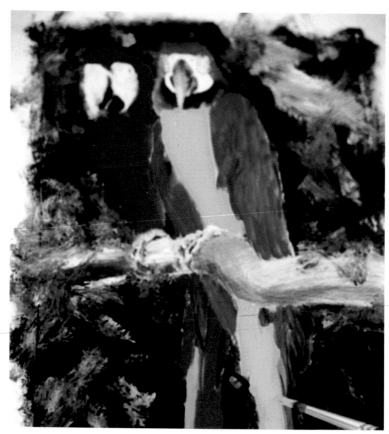

6.

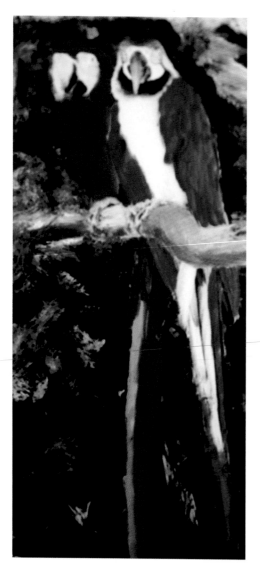

5.

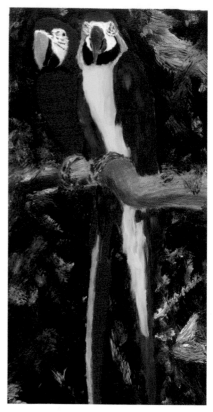

Completed *Brothers Macaw*

5. I brush some Cadmium Yellow Deep onto the tail feathers to complete the brilliant plumage of the first bird. Then I begin on the second, using a blend of Ultramarine Blue and Mixing White and applying heavy color with a medium harder-bristle brush.

6. I complete the plumage of the second macaw by adding a mix of Sap Green and Mixing White to the head and around the neck, then a brilliant Cadmium Yellow Light right out of the tube. The last details remaining are the face areas and claws. For the face around the beaks, I brush on some Titanium White. I use a combination of Yellow Ocher and Titanium White on the beak of the scarlet bird, then add a heavier brown on the second. I add careful Ivory Black detailing around the eyes and head. For the claws I use Payne's Gray and Titanium White, with a bit of Ivory Black for shading. I now have a pair of free birds, with no cage in sight.

DEMONSTRATION 16: JEFF GORDON'S #24

In addition to being a baseball junkie, I am a race nut. Early in my photo-painting work I had the opportunity to photograph the San Antonio Grand Prix in 1989 and 1990, and to do the official posters and program artwork for the 1992 Grand Prix du Mardi Gras in New Orleans and GI Joe's Grand Prix in Portland, Oregon. These were all International Motor Sports Association races and I really enjoyed cutting my teeth there. I then had the pleasure of being commissioned by Target Stores to photograph the Ganassi Racing Team's championship cars in 1997. But I have not yet had the opportunity to photograph a NASCAR event. I am eager to do so because it is an enormously popular sport and the cars are perfect for my technique. The closest I have come was when Jeff Gordon's #24 backup car was on display at a venue in Austin. I printed the black-and-white on Luminos RCR. Since I knew I wouldn't want to rely on memory for the car colors, I also took color snapshots for reference.

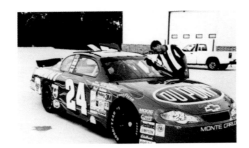

1. Knowing that I'd be altering the background, it was no problem that the car was drawing fans. The first step I take is to apply Titanium White generously to the back-ground, obscuring all the unwanted detail there.

2. I further disguise the location by adding some Payne's Gray, allowing it to blend in places and be heavier in others. Above the roof of the car I use it to create an abstract stream-lined pattern. I then add Ivory Black to the pavement in front of and

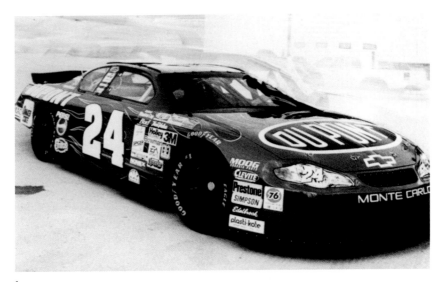

1.

2.

below the car. With these steps, I have pretty effectively taken the background out of play. I then

decide an organized plan will be most effective to cope with the many colors on the car.

3.

3. Beginning with Cadmium Yellow Deep, I carefully paint all the signs and other details requiring that shade of yellow. I use Ivory Black to darken the windscreen and side windows with an abstract play of light and shadow. I then start in with my favorite red mix of Cadmium Red Medium and Deep. Although there is a large area for the red coverage, I feel detail in the car is important so I use a smaller pointed brush for accuracy.

4.

4. My next application involves the royal blue chassis. I combine Phthalo Blue and Mixing White to achieve the desired hue and again use the smaller pointed brush for accurate painting.

5. I work around the car one color at a time, going slowly and patiently to get an accurate representation of the vehicle. I knew that the intense colors of the Winsor & Newton alkyds would make the right impression in this photopainting.

5.

6. As I finish up the last detailing on the car, I examine the foreground and background and decide to place the vehicle on the track rather than simply in some abstraction.

7. A thick application of Titanium White creates the appearance of a rapidly receding white wall behind and above the car. I then add the three principal colors from the car—blue, red, and yellow—in long streaks along this wall. I also add the same colors to the pavement in front and back and along the side of the car. I think I've done justice with this trade of places from parking lot to race track.

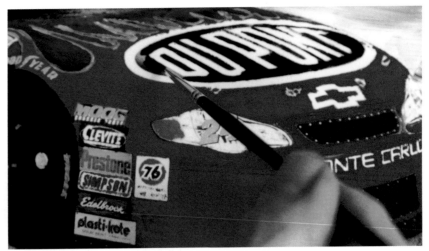

6.

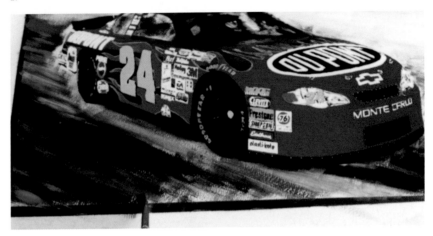

7.

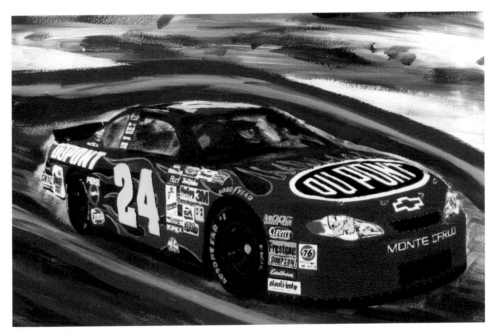

Completed #24

DEMONSTRATION 17: TEXAS BALLET

In my tour chapter I described the experience I had with Texas Ballet, *my image of a cowboy, a longhorn, and a dancer (see page 16). For twelve years I had been longing to see how the photograph would have looked as originally intended. Now, through photopainting, I was able to "trade places" and put the three subjects where I wanted them, namely on the Texas plains and not in a pen. I chose a companion negative and created a black-and-white on Luminos Classic Charcoal paper.*

1. My first step involves adding the "big sky" with Phthalo Blue blended with Titanium White, using more white closer to the horizon. I exercise as much care as possible not to paint over the subjects, while at the same time trying to get long-flowing strokes with the flat-tip brush.

2. I add some Vandyke Brown, Burnt Sienna, and Burnt Umber along with Mixing White to my palette and proceed with the "plains." Soon I have three shadow-less "cutouts" out there in the wilderness.

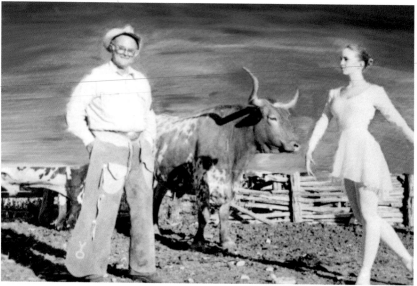

1.

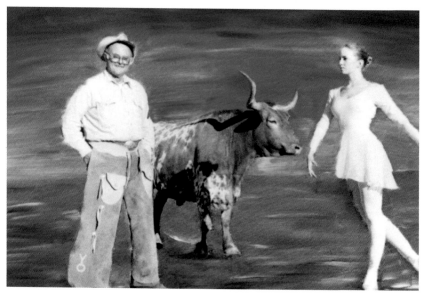

2.

3.

4.

3. I paint the cowboy with a smaller pointed brush, doing his shirt with a mix of Titanium White and French Ultramarine, and use white and Raw Sienna for the hat. For the chaps I use mostly white and Raw Umber, with white and Yellow Ocher for the tops. For the longhorn, again with a smaller pointed brush, I use a blend of Burnt Sienna and Vandyke Brown, varying the intensity of each to achieve the proper redness of the sienna in the highlight areas. I then add the figures' shadows and some stray marks that could be rocks, vegetation, or simply "irregularities" to give the image a more-natural appearance.

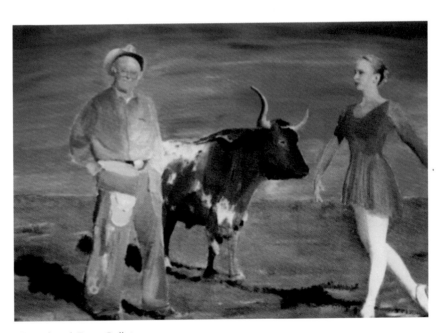

Completed *Texas Ballet*

4. For the dancer I choose Rose combined with Mixing White to create the pink for her costume. For her tights I use pure Titanium White in the highlight areas, mixing in some Payne's Gray for the shading. I consider this among my most-favorite photopaintings ever.

Love of the Game

Baseball is one of my most-cherished pleasures. My dad passed it on to me and I did the same for my son. For a while that passion had diminished, but watching Nolan Ryan, just a few years my junior, pitch no-hitters when he was into his forties made me remember how much I loved the game. We love legends. Casey Jones and Babe Ruth delighted our predecessors and they will our successors. Today's legend for me is Mark McGwire and I feel honored to have watched him in action on a few occasions. He played with a poise and loyalty that speaks of his character. During the magic season of 1998, when he and another good guy, Sammy Sosa, went down to the wire setting records, the way Mark McGwire conducted himself, and how he shared the moments with his son, made me want to pay tribute to him in my work, just as I did for Ryan earlier.

DEMONSTRATION 18: MARK McGWIRE #25

1.

2.

I chose this image because it was taken from the stands where the ordinary fan might sit. You can almost feel the breeze from the swing, even this high up. The picture was printed on Luminos RCR.

1. I begin by applying flesh tones to the fans with a smaller pointed brush, using a mixture of Burnt Sienna and Titanium White and making some complexions darker and others lighter.

2. I add an abstract palette of colors to suggest a variety of different clothing, continuing to dab on paint with a small pointed brush until I achieve the Pointillist look I want in the stands. For the black shading I run the brush abstractly among the colored areas, creating the illusion of shadows.

3.

4.

5.

3. I proceed to use the same brush to deepen the shadows in the dugout with Ivory Black.

4. I add some dabs of team colors and flesh to the players in the dugout. I also paint the roof of the dugout and the railing in front with a combination of Sap Green and Mixing White.

5. I paint the clay in front of the dugout, the track that runs around the stadium, in a blend of Burnt Sienna and Mixing White, adding some Ivory Black in the deeper shadow areas and blending it with the clay mix. I'm not filling it in solidly; I want it to have slight irregularities from place to place. I then paint the grass with a combination of Sap Green and Winsor Lemon with a small amount of Phthalo Green for the infield grass. (Too much Phthalo Green makes the grass too emerald.)

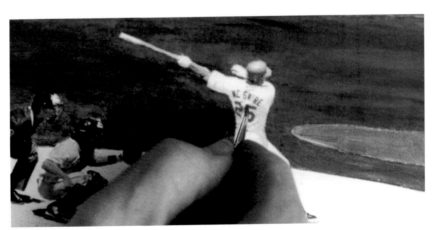

6.

6. My final steps include the details of the individuals in the picture, McGwire, the catcher, and the umpire. McGwire's uniform is Titanium White, with a light mix of Ivory Black and Titanium White for the shadows and Cadmium Red Deep for the Cardinal red. The catcher's uniform is a mix of Payne's Gray and Titanium White, with Ivory Black for the black portions of the uniform. For the umpire I mix Ivory Black and Titanium White for the trousers, Prussian Blue and black for the shirt, and a bit of Cadmium Red Deep for the trim. For the skin tones of the figures I use a combination of Burnt Sienna with Titanium White. I then finish the clay portion of the batter's area and add shadows with Payne's Gray blended into the clay color. I think I have achieved a different kind of sports art photo-painting, one that offers another perspective on the game. (See page 82 for the completed image.)

Reworking: Enhancing a Handtinted Image

Believe me, this really is a version of photopainting. Why then do I feel like I am hawking the Emperor's New Clothes? Let me begin with my definition of "reworking." It is similar to an artist adding paint strokes to an art print of his or her work to add value to the reproduction. However, the distinction is that I "rework" a print by adding paint to enhance a finished handtint. It is a subtle effect, but nonetheless a valuable and effective technique. I start off not with a black-and-white print but with a completed handtint.

DEMONSTRATION 19: SAN JOSE MISSION

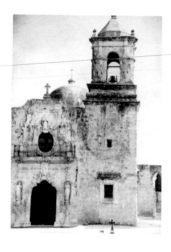

1.

2.

Here I am working from a traditional handtint of San Jose Mission in San Antonio. The handcoloring followed the basic transparent application of Marshall Photo-Oils, rubbing down the application with cotton balls so the tint affected the print's color without leaving any surface texture. The sky was tinted with Sky Blue and the bulk of the mission Background Tan (a color now discontinued). The doors were tinted with Verona Brown. For the photopainting I attempted to match the existing colors, adding paint texture to create a relief effect on the flat surface of the print.

1. The reworking technique I employ is very careful and precise, so I use the smallest pointed brush and work extremely close in. I begin by enhancing the shadows, deepening them with an application of Ivory Black. I use the dry-brush technique (see Chapter Three, page 55) on any lighter shading I also want to enhance.

2. I proceed to work the dome using a mix of Raw Sienna and Titanium White. My intent here is to lay the paint application on carefully but with enough thickness so that it can be seen as a painted area on the surface. I then add the same mix to the intricate carved areas on the mission's facade, particularly around the door.

4.

3.

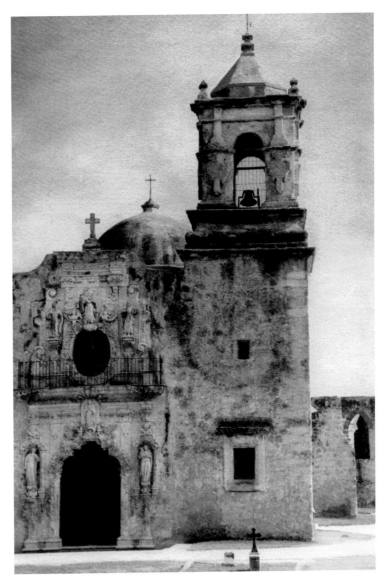

3. Next I apply Vandyke Brown to the carved features in the wooden door. I keep a touch of Titanium White available on the palette in case I decide to delicately accentuate the light falling on a carved section.

4. My final step is to apply a touch of Burnt Sienna to the small rusted iron cross in front of the mission. As I indicated at the beginning of this demonstration, the effect is subtle but it does enhance the image. Since the application follows the same colors as the underlying tint, it's a bit difficult to see the changes; nonetheless I recommend this as an alternative photopainting approach that you might on occasion use effectively.

Completed *San Jose Mission*

Follow the Leader

When I saw my first photopaintings that used subjects other than sports, I was very enthusiastic. I admit that until that point I really had not investigated too many subjects apart from sports. So I really began my own process of discovery because I wanted to see the effects of the photopainting technique on a variety of different subjects. In some cases, I had not yet done a particular image because I knew it wouldn't work in its current form (as in *Brothers Macaw,* which I couldn't paint until I figured out how to transform the ugly cage in the background). But there were other images for which I had created very successful handtinted renditions and now I wanted to compare them with a photopainted version.

DEMONSTRATION 20: FOUR DANCERS

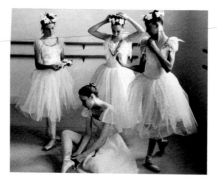

I published this image as a successful tint on Luminos Photo Linen in Handcoloring Photographs. *Yet here I am, fiddling with a good image. Never one to heed the "If it ain't broke, don't fix it" maxim, I decided to rework the picture, this time beginning with a black-and-white print on Luminos Classic Charcoal fiber photo paper.*

1. Since I feel the facial features are very important, I decide to be more precise in this area of the photopainting. Working with a small pointed brush for greatest accuracy, I blend in the flesh tone mix of Burnt Sienna and Titanium White. I use Cadmium Red Deep for the lips and a minute amount of it on the cheeks.

2. I continue modeling all the exposed skin areas until I'm pleased with the subtly blended effect.

1.

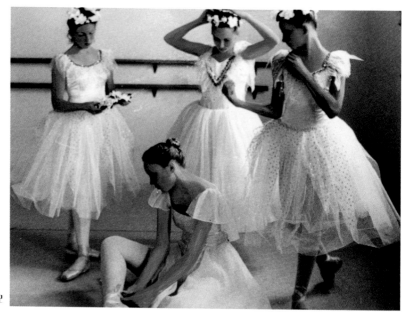

2

3. I decide that I want a looser approach when applying color to the walls. I choose a mix of Magenta and Titanium White and apply it with an angled flat brush. Since I want the walls to reflect light and shadow, I blend in extra Titanium White as necessary for lighter areas and Payne's Gray for shadows. When the walls are done I will paint the bars with Vandyke Brown.

4. The wide, gauzy skirts provide a perfect opportunity to illustrate an Impressionist approach to light and shadow. I choose a mix of Cobalt Blue, Dioxazine Purple, and considerable Mixing White for the dresses. Using a medium-pointed brush, I paint with considerable abandon. Before starting on the seated dancer, I will first paint the floor and shadow to the left. I use Vandyke Brown and Ivory Black for shadow, with Titanium White and Burnt Sienna to lighten certain portions.

5. Since the seated dancer is dressed differently, I choose a mix of Permanent Rose with Titanium White for her costume. In the deep shadows around her arms, I add some Payne's Gray to the mix for verisimilitude. Next I paint the legs on the left of the picture, where the floor is already done, using Titanium White and Payne's Gray to catch the highlights and shadows. I then complete the floor to the right of the seated dancer and paint the legs on the right last. Finally I emphasize their floral garlands with Winsor Lemon. Looking at the end result, I see how I might stand accused of trying to imitate Degas.

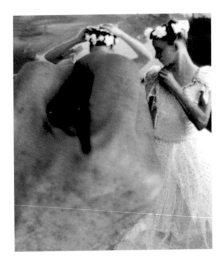

3. 4.

5.

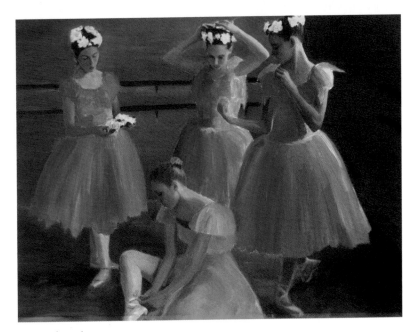

Completed *Four Dancers*

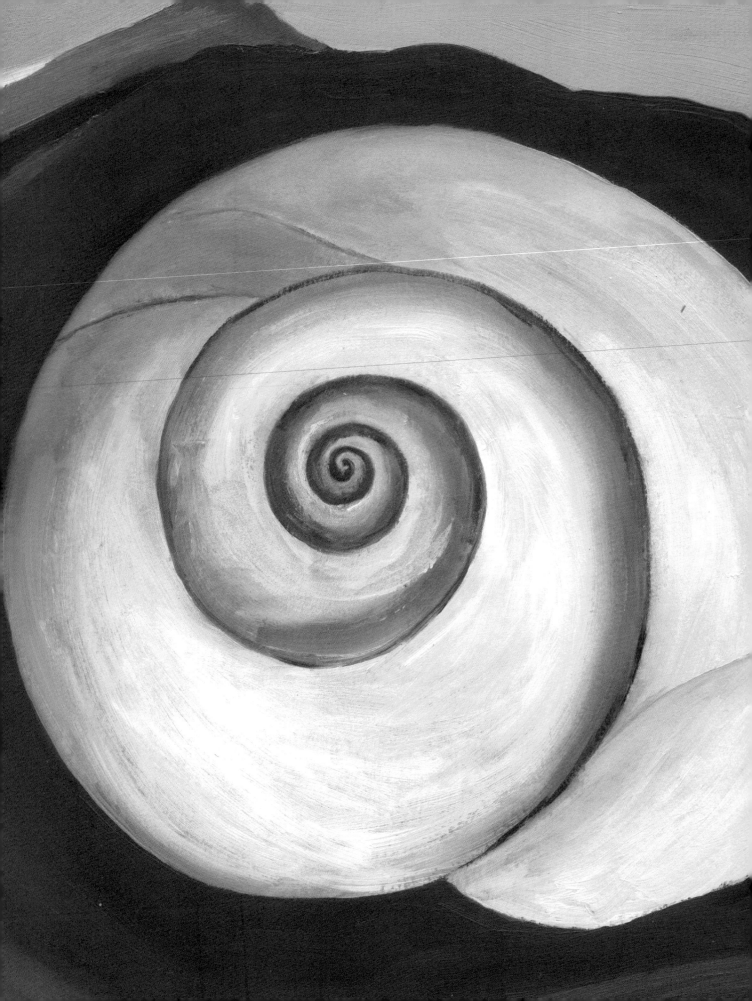

Emulating Favorite Artists:
A Sincere Form of Flattery

As I began teaching myself photography, the Impressionists had a great influence on me. I gravitated toward the sense of beauty that their paintings evoked. I also sought to re-create Rembrandt's handling of light in some of my studio work, to see how the effect would translate to photography lighting. After I found myself defending the Degas comparison, I began to think that in fact there might be validity to the idea not only for the subconscious influence, but as an intended direction. In other words, why not create a photopainting deliberately in the style of an admired artist?

Such an approach might stem from curiosity: "How close can I come?" But on a more-important level, doing so provides a tremendous opportunity to study the great artists. It has taught me to be far more attentive to their works. I am not talking about doing something to sell, but creating a photopainting as a tribute to a favorite artist and to advance your development toward attaining greater skills. After all, artists talk with each other, critique one another's work, and learn from one another. You can learn from them, too. Learning is a continual process throughout life, no matter where you choose to draw inspiration.

In some cases, I already had photographic images to experiment with, but as I proceeded I decided to set up some images to photograph in the style of certain artists. Borrowing my wife's shell collection, I shot a nautilus in a square 2¼ format against a black background. Then I took out one of her O'Keeffe books and set about seeing how close I could come to copying this legend. I congratulated myself on the results. Who was I trying to please? Myself.

OPPOSITE:
Tribute to O'Keeffe

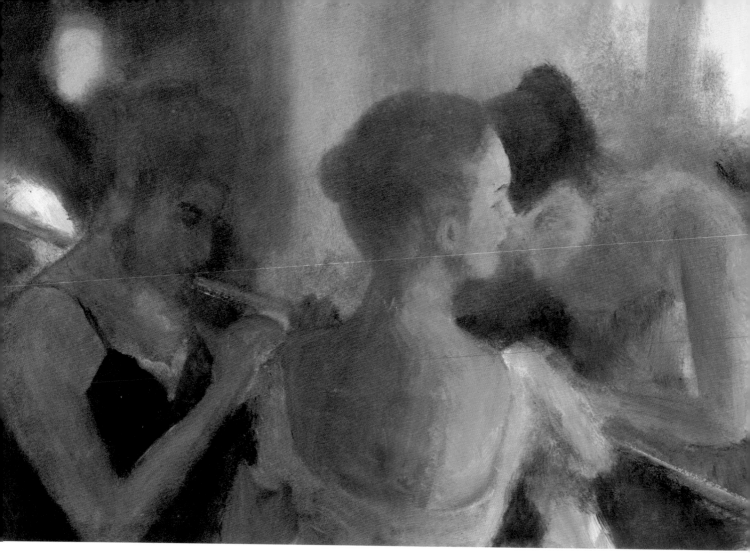

Homage à Degas

This is the work that caused the tempest in the teapot, the "half-assed Degas." Actually the photograph dictated the treatment, but I liked the way it looked anyway. I have to admit that there was also a "tongue in cheek" element at play. Since I was being accused of imitating Degas, I figured I might as well set out to "imitate" a whole bunch of other artists. It turned out to be even more fun than I expected and I certainly learned a few things along the way.

Although I originally did not purposefully set out to "re-create" a Monet, who can see a scene like this bridge over a pond without thinking of him? So when I was searching around for images I had already worked on (I had done this as a tint for a catalog cover), I decided to do a photopainting with some Monet characteristics. I did not take it nearly as far as I might have in the direction of Impressionist photopainting, but the influence is there, certainly as much in the technique as in the choice of subject.

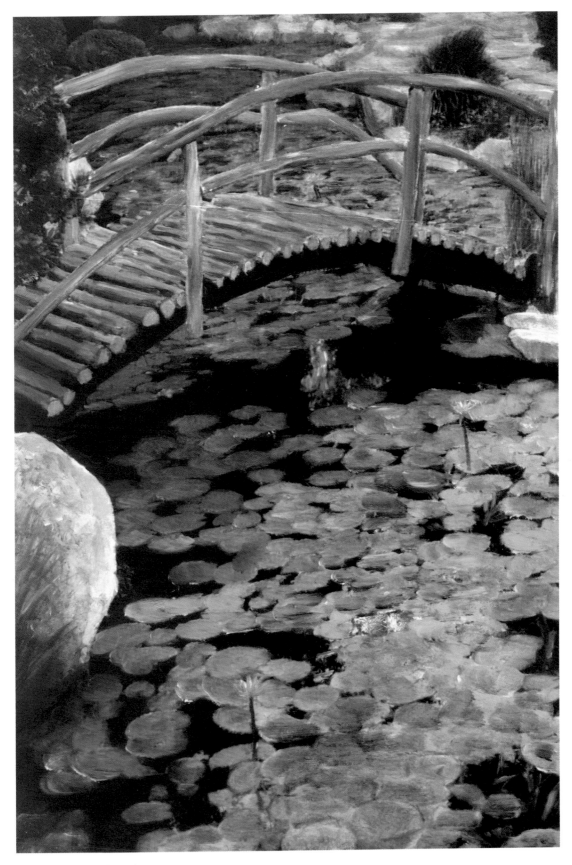

Lily Pond and Bridge

Newton County Courthouse, tint

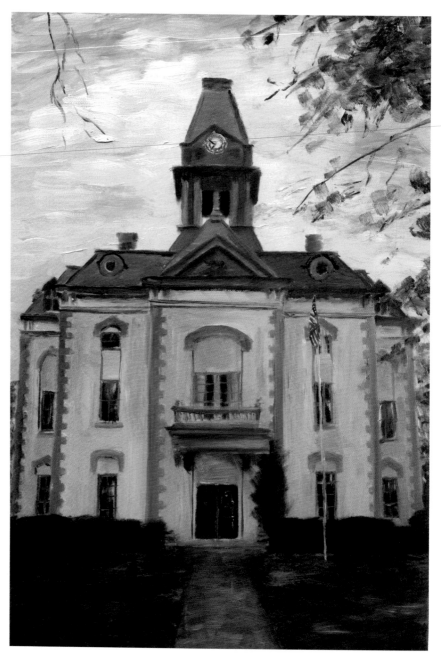

Newton County Courthouse, à la Van Gogh

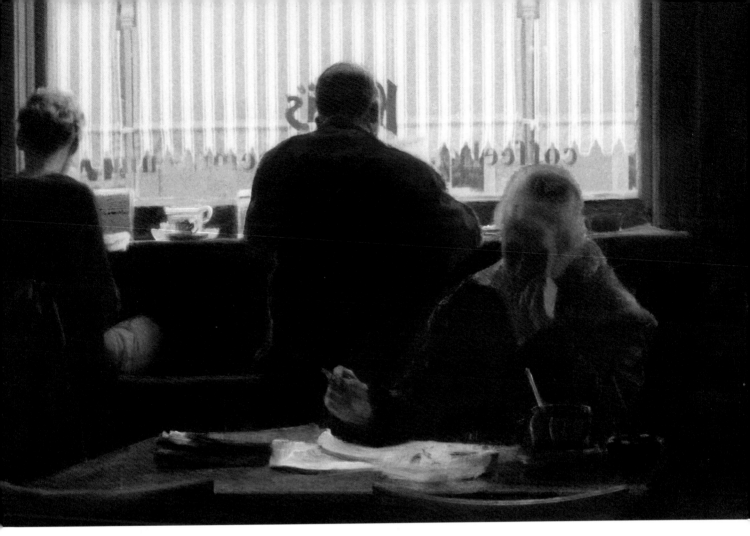

Sunday Morning Coffee

When I began researching certain artists, one of the books I checked out from the library was a volume on Van Gogh. Looking at some of the buildings he painted, I thought that the Newton County Courthouse from my collection of over 180 courthouse images would be ideal. So, armed with the tint and my Winsor & Newton alkyds, I opened to an appropriate illustration in the Van Gogh book and set out to "interpret" the Newton County Courthouse as Van Gogh might have.

Here is another image that I had also done as a tint and was curious to see as a photopainting. I liked the moodiness of this authentic New Orleans coffee house and wanted to see how the photopainting tech-

nique might affect it. The finished work, I realized, bore a similarity to one of my favorite artists, Edward Hopper, and I loved it.

About five years ago, a friend approached me with a task. He wanted a special gift for a friend of his who had played hockey in the pros but whose favorite memories were of his days at Notre Dame. Among his old photos was a grainy 4x5 of him playing on an outdoor rink, just him and the goalie in the fading evening light with snow-covered houses and trees barely visible across the street. He asked me if I could turn it into a photopainting. When it was finished, it also resembled what Hopper might have done. When you feel a kinship, even a sense of awe, that artist has truly affected you.

Inspired by Warhol

Van Gogh's Pierce Arrow

My Warhol effort is a bit campy, but then so was he. He might have appreciated it. Again I was curious as to how a photopainting would look done in a certain artist's style. In a way I gained a greater appreciation for his work from reading more about him.

Since many great artists never got the proper recognition during their lifetimes, I thought it might be appropriate to consider how Van Gogh might have reacted to a Pierce Arrow of his own parked in his driveway. Seeing the results of my "time travel" experiment, I feel I have strayed far enough afield and should return to those subjects that bring me my own pleasures in photopainting. I had a lot of fun, though, with this fantasy speculation.

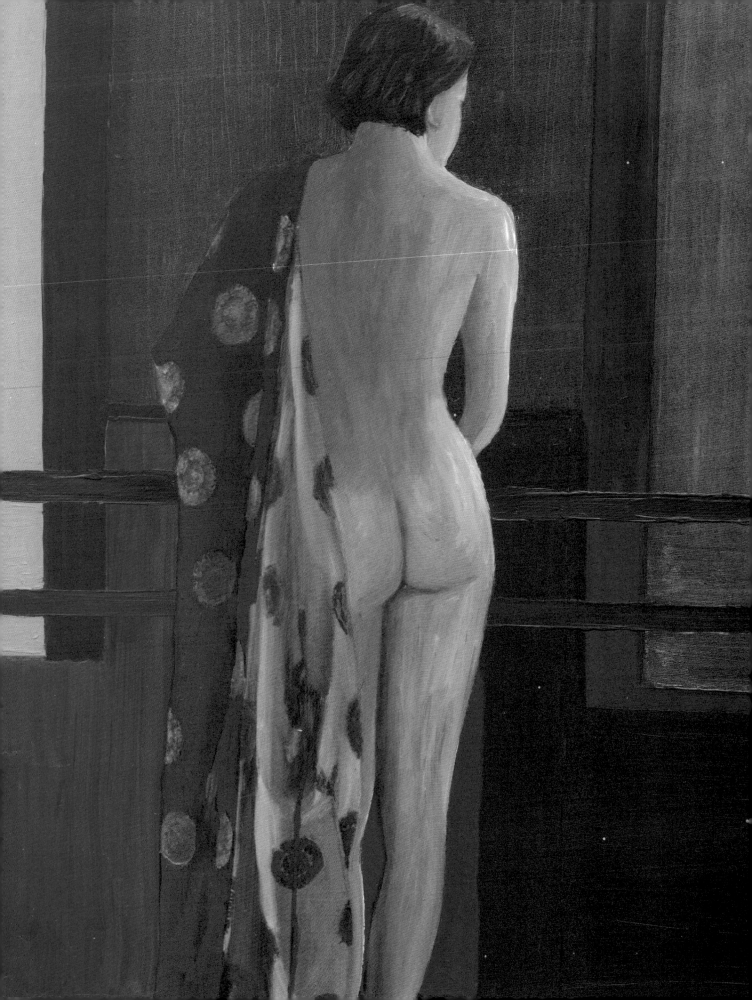

Photopainting Showcase: The Gallery

Throughout this book I have provided you with many finished examples of what I've done so you can familiarize yourself with the wide range of possibilities that photopainting offers. The series of twenty step-by-step photopainting demonstrations was designed to teach you how the process works. Now I will take you on another little tour of my work, focusing on three subjects that I especially enjoy photographing and painting—sports, ballet, and beauty.

Earlier I encouraged you to follow your passions. Part of that path consists of opportunity and discovery. There is also an element of impracticality in the sense that one's pursuit of art and expression can conflict with one's commercial needs. I can make no claims about resolving that dilemma.

As one proceeds along one's path, his or her work can begin to coalesce among those subjects most important to that person. It might even come as a surprise, such as my sports and ballet art did for me. With all the experienced outstanding photographers working in the field, I thought it the height of presumption in my forties to even consider beginning to explore the subject with my camera, this in spite of my love of sports. Yet I discovered I could present my passion for sports in my own unique manner and over the past

decade I have created work I am very proud to claim as my own.

Perhaps the least expected body of work I have created has been with ballet since I had never danced or even seen performances until well into adulthood. It was the enchantment of the grace and beauty as well as the romance of the traditional elements toward which I gravitated. Had someone asked me when I began photography as a career where my work would take me, I doubt that I would have even considered ballet. How life can surprise one.

On the other hand, my life-long love of female beauty has evolved into a substantial body of work. I have tried to be particularly careful with this work as I want to honor the subject and have it be appreciated by women as well as men. While I have not shied away from beauty in its sensual aspect, I have chosen to avoid a pattern in which the work becomes trivial and devoid of content.

I hope you enjoy the showcase.

OPPOSITE:
Nude with Robe

Sports

At its best, sports represents individuals and teams competing within official rules and long-established traditions to their limits of excellence and sometimes beyond. It becomes even more pleasurable when the individual exhibits values I respect. I wish to celebrate that.

My first three images honor the pitcher who brought me back to baseball and permitted me to experience the thrill again as I did as a child. His accomplishments as an athlete will likely never be superceded. His stature as an individual and a gentleman merits even greater respect.

Nolan Ryan: The Art of the Pitch

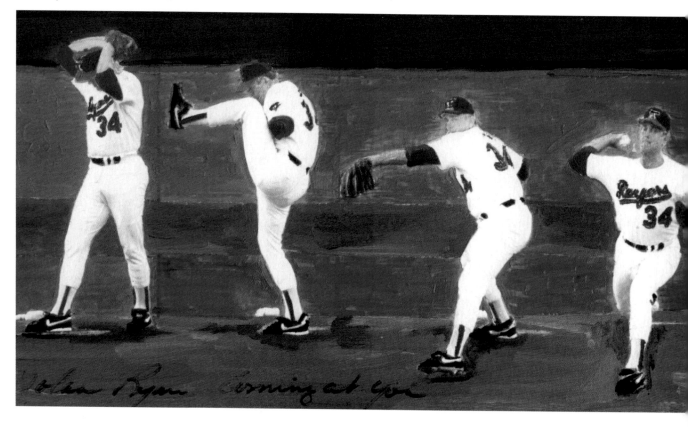

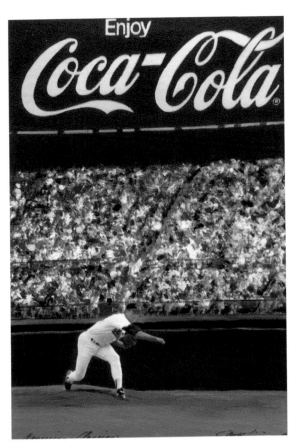

American Classics

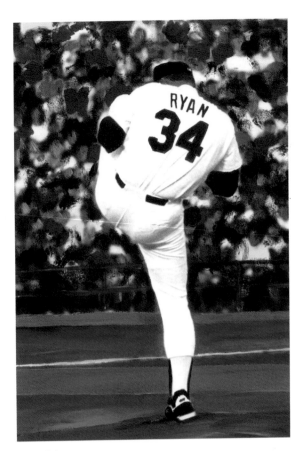

Ryan 34

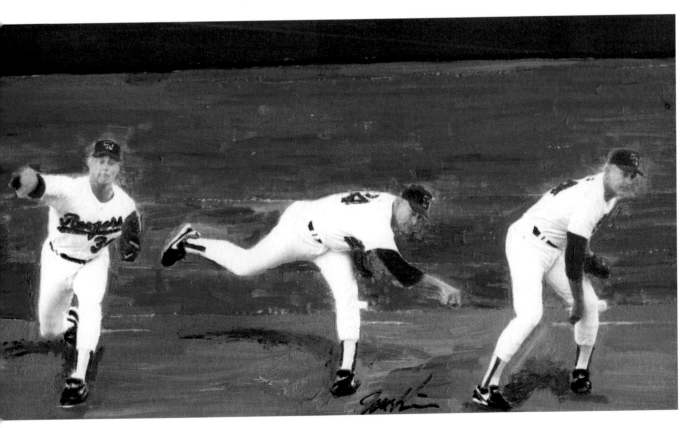

Yankee Stadium, the Bronx, New York, Opening Day, 1986, First Pitch

Field of Dreams was a movie that touched me on many different levels. Shortly after seeing it, I decided to create an indelible memory with my then thirteen-year-old son and head for the only four baseball stadiums that remained from when I was his age. We also took a detour out of Chicago and actually visited the place in Iowa where the movie was filmed. It was fabulous. We even got to play along with other tourists who were there, and it was free to boot. Prior to this trip, I had only visited one of the four, Yankee Stadium, where on my first visit I had recorded the first pitch of the 1986 season, my first sports photograph since high school.

Several years later, in 2000, I boarded a Greyhound bus and visited all thirty major league ball parks on a fifty-four-day odyssey. I took panoramic shots of every one to produce a collection that will eventually include a photopainting of each of them.

Skydome, Toronto, prototype

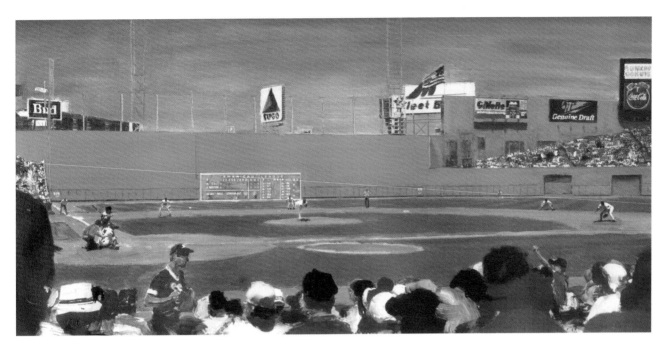

The Green Monster (Fenway Park, Boston), July 4, 1994, detail

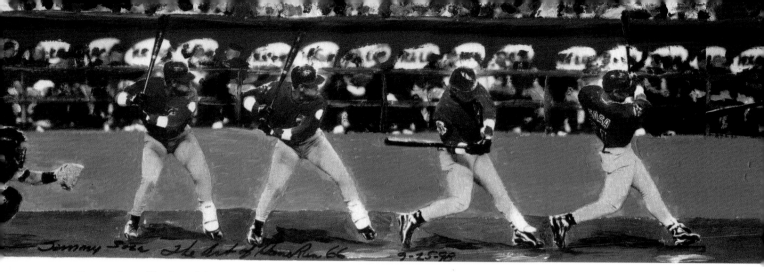

Sammy Sosa: The Art of the Home Run #66

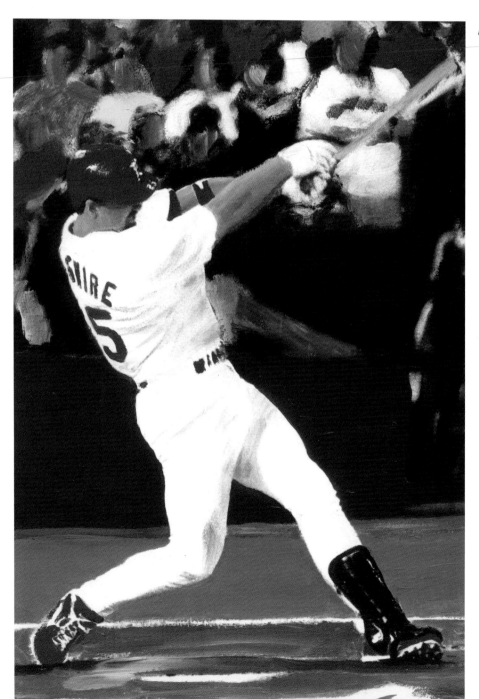

120

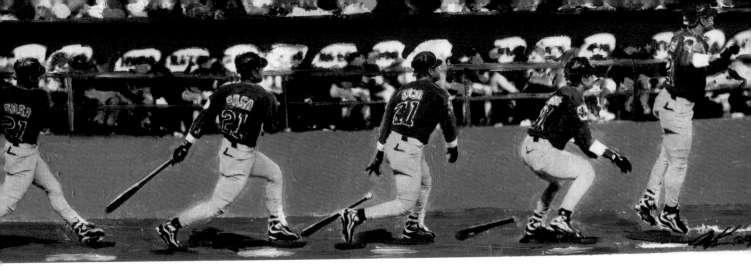

The home run is the single most dramatic moment in baseball, and home run feats from Ruth to Mantle and Maris to Big Mac and Sammy have become part of the legend and myth of the game. I was privileged to be caught up in the magical season of 1998, which will live with me all my days. I also managed to catch history in a bottle by recording Sammy Sosa hitting number sixty-six, which at that moment in baseball history was a first. McGwire hit his sixty-sixth an hour or so later and four more in the next two days to set the record at seventy.

Since I only began photographing and photopainting sports seriously a relatively few years ago, I wondered how I might have done players and events from the past. I visited the Baseball Hall of Fame in Cooperstown, New York, on my 1994 trip with my son and discussed the possibility of creating photopaintings from images in their archives. I did the two on page 122 for myself only, just to see how they would look. I worshipped Mickey Mantle as a kid and I can still remember trying to figure out the headline I read about Larsen's perfect game in the 1956 World Series.

I took a very different direction in the photopainting *Baseball Haiku*, seeking with a still life to convey a sense of how baseball can bring poetry to one's life. To me this image evokes emotion, nostalgia, and memories.

Baseball Haiku

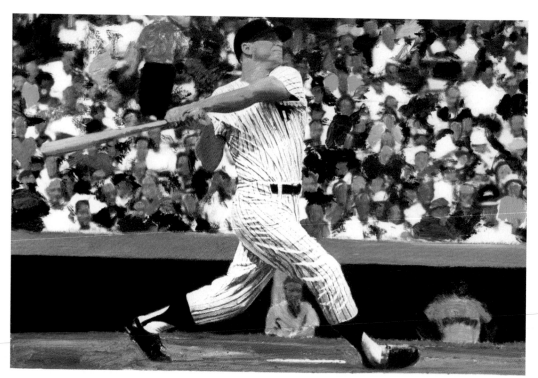

The Mick As I'd've Done Him

Larsen's Perfect Game

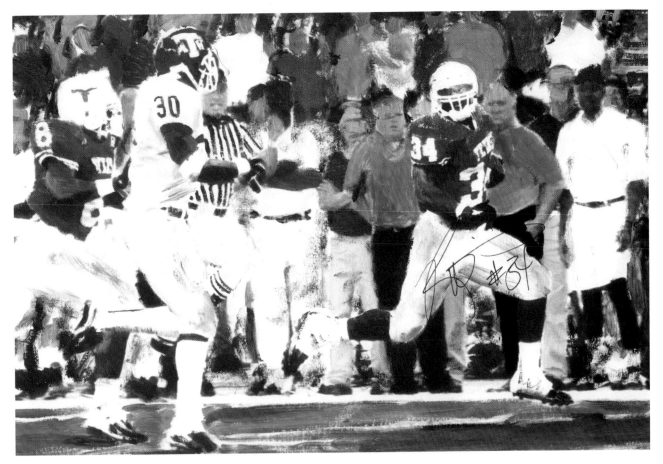

Ricky's Record Run

Football is as Texan as cowboy boots, and anyone who grows up here is spoon-fed the sport from the start. Girls want to be cheerleaders and guys dream of being the star player. I grew up small and didn't like pain, so my football career ended as a tackling dummy on the junior high scrubs. However, it remained in my blood and I still enjoy the sport, though not nearly as much as baseball.

After doing the photography for a handcolored poster of the Dallas Cowboys Cheerleaders, I was invited to the sidelines. Although the Cowboys had a lackluster year, they had a number of Superbowl victories ahead and the quarterback in the photopainting was their star. I think this photopainting captures the color and excitement of the game. The Giants won handily.

Giants' Defense

I was in Vietnam during one of the most memorable plays in the University of Texas football history, during the so-called "game of the century" with Arkansas in 1969 for the National Championship. I heard it on the radio during the overnight hours in Saigon and my heart almost stopped during the fateful play, a fourth-down and two pass that went for a long completion and led to the Texas victory by one point.

The day after Thanksgiving in 1998 I happened to be on hand for what I consider the other greatest play in the University of Texas football history, Ricky Williams' 60-yard touchdown record to set the NCAA record for most rushing yardage. I saw it unfold through my 300mm lens and captured the moment in a memorable photopainting. What's not to love about the action and color of a football game, as seen in *Giants' Defense*.

San Antonio Grand Prix

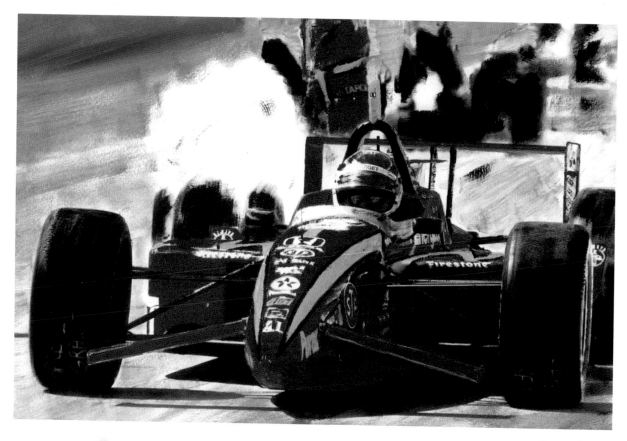

Out of the Pits

GI Joe's Grand Prix Poster

I already wrote a bit about my enjoyment of automobile racing in the description that accompanied the illustration of Jeff Gordon's *#24* (see page 95). Suffice it to say that my initial experiences with the sport hooked me for good and the photopaintings that emerged presented the color and excitement effectively.

Ballet

My enchantment with the ballet has certain aspects in common with my other enthusiasms but is in some ways unique to the subject. I appreciate the intensity, the passion, the excellence, and the athleticism that ballet shares with sports, and I celebrate these qualities in my work. But I am also drawn to the beauty and grace of the dancers and the settings, which hark back to my admiration for the work of Degas. Even early on, my photographic images were influenced by an Impressionist quality. On my first visit to the Metropolitan Museum of Art in New York, I distinctly felt a sublime chill as I beheld the Degas collection and witnessed up close the work that had influenced me over time and distance. Although I try not to be imitative and I vary my approach to the individual images, I nonetheless find that my photopaintings naturally reveal this influence, particularly with the subject of ballet. I plead guilty to appreciation for, and being under the influence of, the original masters.

Dancer in Studio

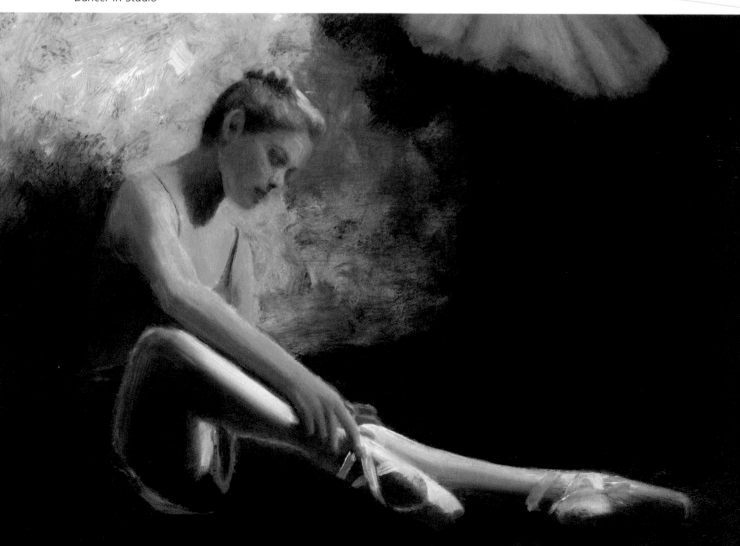

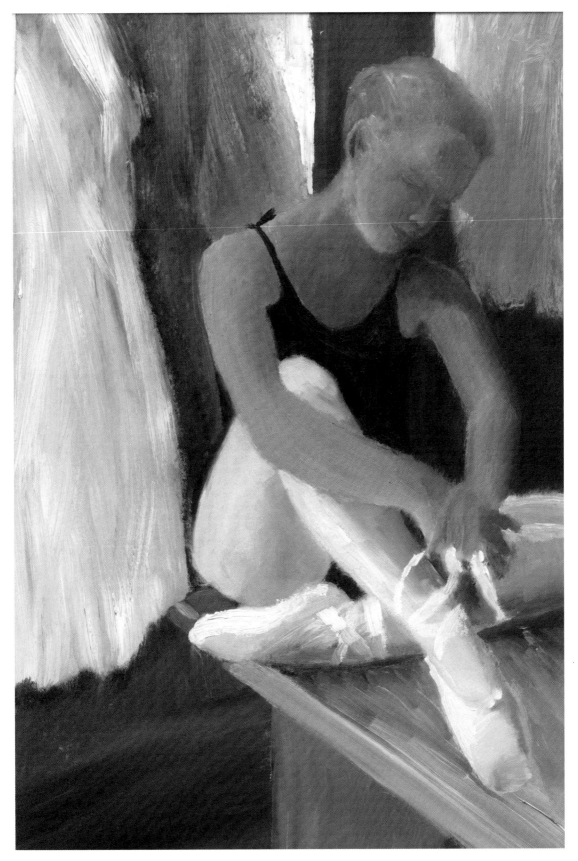

Dancer on Bench

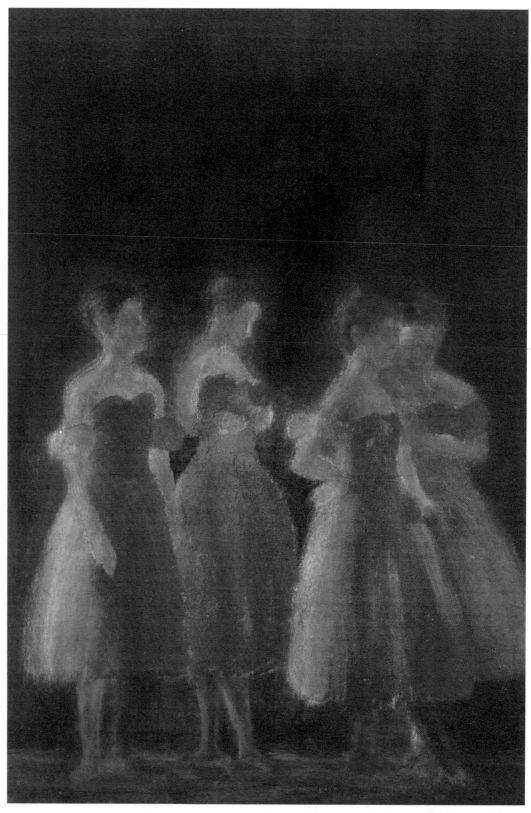

At Rest

OPPOSITE: *Sharon*

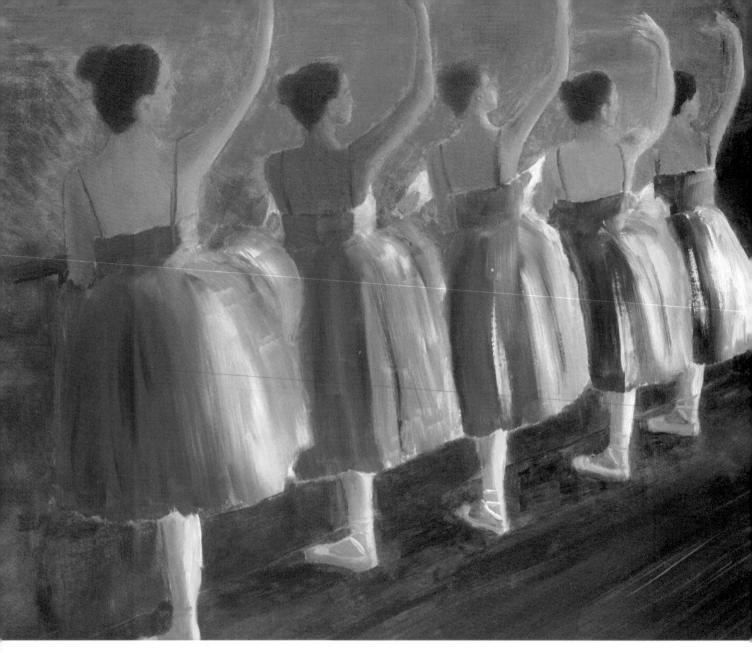

Dancers in Studio

Dancer 1

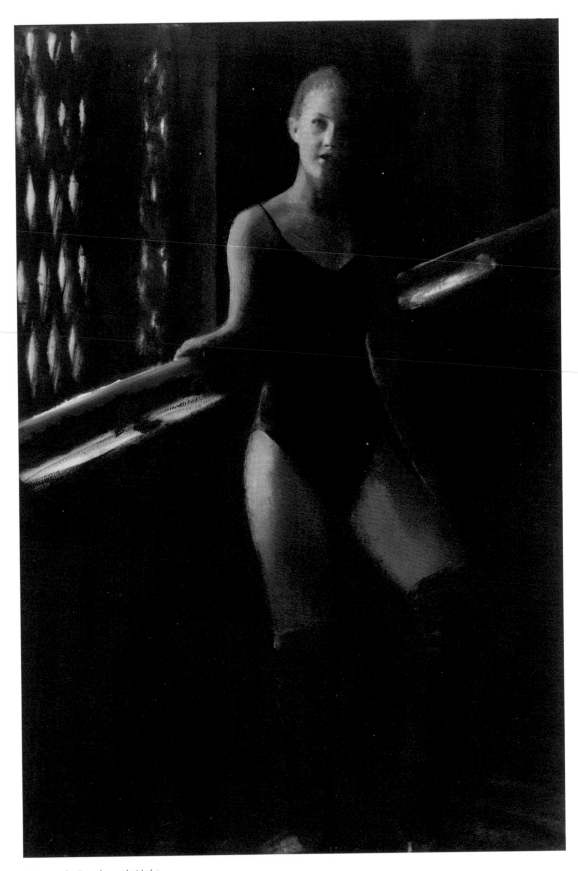

Dancer in Rembrandt Light

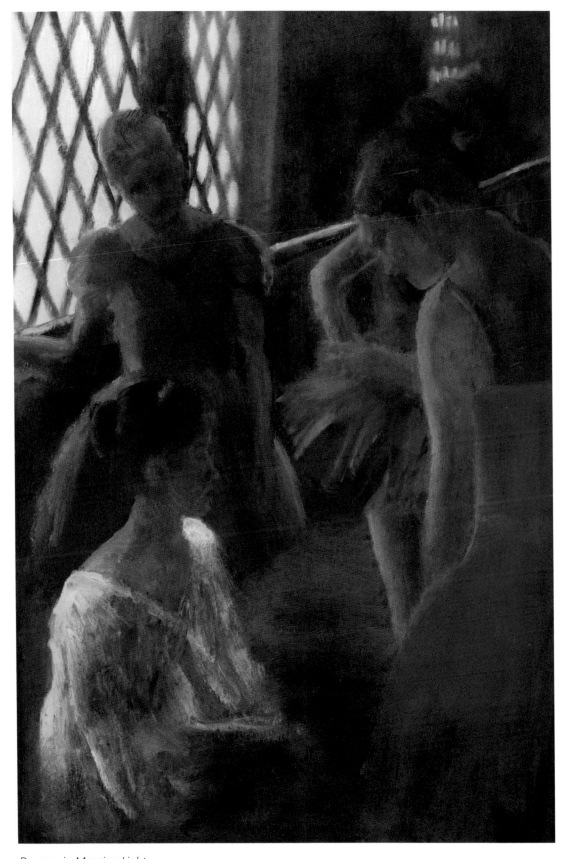

Dancers in Morning Light

Beauty

Beauty, as the cliché goes, is in the eye of the beholder. In that sense, I seek to capture and interpret that which enchants me. Often it is, as the French so adroitly do not explain, a certain *je ne sais quoi,* perhaps a gesture, a look, an attitude. I find myself drawn to beautiful subjects and constantly question whether I can celebrate that beauty without being naive or rendering it trivial. Obviously there is much hurt and pain, destruction and cruelty in the world of human experience. All the more reason to strive for the worthy goal of aspiring to excellence, higher ideals, a better future. Thus I celebrate beauty in my work, and I find it often in the female subject. On occasion I have managed to capture images that allow me to display moments perhaps inconsequential, frivolous, certainly fragments of time, but nonetheless a glimpse of beauty.

Alicia

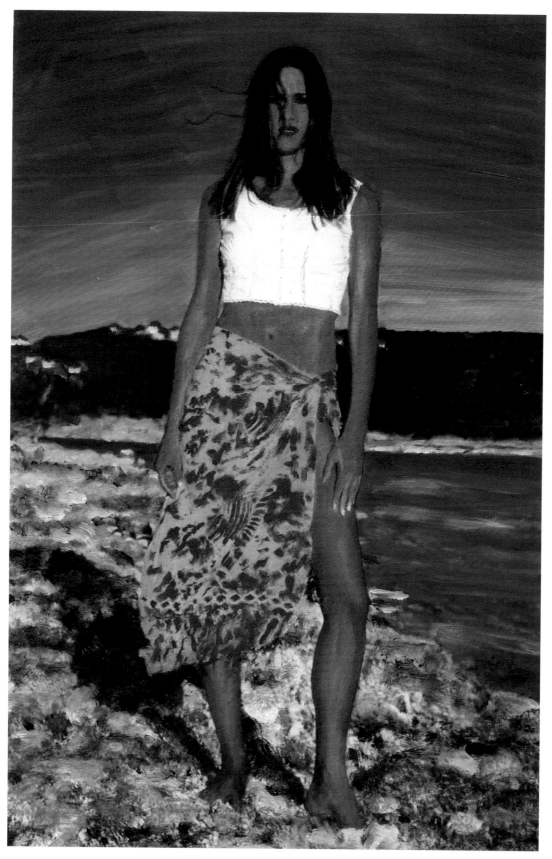

Mediteranee

California Dreamin'

OPPOSITE: *Oriental Motif;* ABOVE: *Nude on Blue Couch*

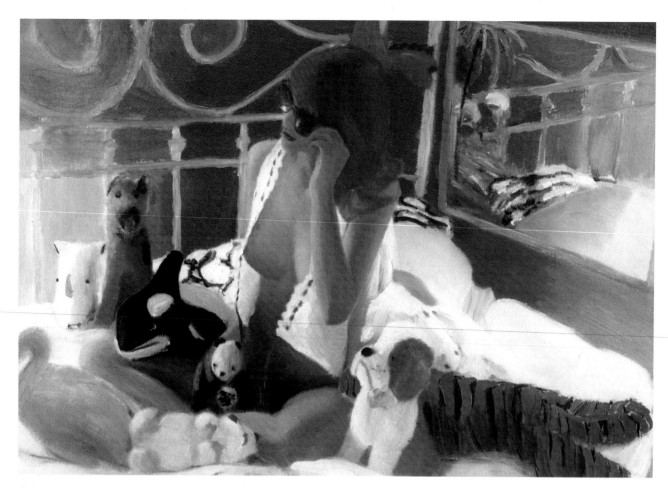

Pets

OPPOSITE: *Nude Preparing for Bath*

Final Thoughts

According to Time magazine recently, scientists have determined that the world will end with a whimper, disappointing those of us favoring a bang, but then you can't satisfy everyone all the time.

I know that photopainting might not satisfy every-one either, but I do hope that this book has at least provided you with sufficient reason to explore the field yourself. I also hope that if you do, you have seen sufficient examples and useful information on how to proceed.

I feel as though I am saying good-bye to a friend in closing this book, for it has been a work of love and intensity, and I have truly enjoyed the time and effort spent.

I'll leave you with this final suggestion. If you have any questions that you feel I might be able to help with, you can write to me in care of the publisher, who will direct the query to me. Or you can reach me by e-mail at Jmckinnis2@aol.com. Of course, those of you who would be interested in obtaining works I have done, or even commissions, are welcome to do the same.

I'm outta here.

Outta Here

Index